MYWAYS

MY WAYS

Edited by Rita McBride & David Gray

Arsenal Pulp Press, Vancouver
Whitney Museum of American Art, New York
Printed Matter, Inc., New York

Text and cover design by David Gray
Cover photograph by Diana Kingsley
Printed and bound in Canada

Library and Archives Canada Cataloguing in Publication
 Myways / edited by Rita McBride and David Gray.
Co-published by: Whitney Museum of American Art, Printed Matter, Inc.
ISBN 1-55152-198-9
 I. McBride, Rita, 1960- II. Gray, David (David Frazer), 1965-
III. Printed Matter, Inc. IV. Whitney Museum of American Art.
PS8600.M98 2006 C813'.6 C2005-907787-5

ISBN-13 978-1-55152-198-5

This project is a copublication between Arsenal Pulp Press, the Whitney Museum of American Art, and Printed Matter, Inc.

ARSENAL PULP PRESS
341 Water Street, Suite 200
Vancouver, BC
Canada V6B 1B8
arsenalpulp.com
Arsenal Pulp Press is one of North America's leading independent publishing houses.

WHITNEY MUSEUM OF AMERICAN ART
945 Madison Avenue, New York, NY, USA, 10021
whitney.org
The Whitney Museum of American Art is the leading institution of twentieth- and twenty-first century American art and culture. An essential forum for American artists since its founding in 1930, the Whitney's goal is to champion freedom of artistic expression and to foster the development of art in America.

PRINTED MATTER, INC.
195 Tenth Avenue, New York, NY, USA, 10011
printedmatter.org
Printed Matter, Inc. is an independent 501(c)(3) non-profit organization founded in 1976 by artists and art workers with the mission to foster the appreciation, dissemination, and understanding of artists' books and other artists' publications.

Contents

Introduction

The site-specific installation artist Gina Ashcraft debuted her public writing in 2001 with the novel *Naked Came the* ****, published by the Kunstmuseum Liechtenstein. Shortly thereafter, she was approached by Uriah Ulrichs to write a column for his magazine *Kunst für dich!* It was then that she inaugurated "Aunt Gina," a celebrated monthly advice column for artists.

In her letters to Herr Ulrichs, Ms. Ashcraft wrote that she needed a "Gina-rama, and what a pleasure when others do half the writing for you (it certainly beats sitting in your studio moving 1,000 tons of titanium around the planet)." Later, in a file marked "Confidential," she admitted to writing the questions and answers herself "once or twice, following my mantra of self-invention as self-awareness"; sometimes she even "let a friend do the whole damn thing" when "I was too tired, drunk, or freaked out to answer. I am a site-specific artist, when all is said and done!"

The "Aunt Gina" column as represented in this anthology may appear rather contradictory, even disruptive, but Ms. Ashcraft was fascinated by contradiction and was never concerned with forcing readers to suspend their disbelief. Unafraid of sudden mood swings

5

or bizarre rantings, she did not shy away from absurd references to herself and the perverse international art world she inhabited. Indeed, it was through these references and absurdities that she constantly reminded the readers that they were not reading about real life but *spectacle.*

The present selection was largely chosen by Ms. Ashcraft, before her timely death in a boating accident off the Florida Keys. Found on her desktop in a file headed "I Did It," the following pages are a testimony not only to Ms. Ashcraft's attempts to deal with themes and problems that are usually left to other disciplines, but also to her brilliance and compassion as an artist and a human being.

The Editors

DEAR
GINA: I really enjoy your column; I always read it first, even before I scan gallery listings or check to see who's featured in the articles. I couldn't tell you precisely why I'm addicted to it, but it's clear you've got something. Art-smarts and life-smarts don't always go together, you know? You're unique. And as a matter of fact, so am I – so please read my letter completely, with an open mind, before you decide I'm a crackpot, OK? I need your wisdom. I'm bringing my agony to you, Gina, because I think I've finally managed to convert my own species of agony into euphoria – through a completely original alchemical – or maybe just plain chemical – formula, and I want your perspective.

My situation is this: I'm sick of nature! Nature has been my soulmate all my adult life, but an abusive one, I'm afraid. To give you some background, I'm a practitioner of that obsolete vocation, landscape painting. I've spent the last few decades chasing the seasons and traipsing through the wilderness, and have garnered more than a few casualties, including bites by rabid raccoons and vicious dogs, a permanent limp because of a trigger-happy estate-owner's shotgun, as well as a bruised shoulder due to a desperate deer hunter's shotgun, pneumonia (twice), skin cancer (two sites: nose and bald spot), poison ivy (numerous bouts), Lyme's disease, and encephalitis (once was enough, in each case)! I've had it with the great outdoors and my outgrown youthful idealism regarding Mother Nature's alleged nurture. What a scam!

How much nurture am I the beneficiary of when I'm puking my guts out for two weeks, barely able to hold up my throbbing head, because I got bit by the wrong mosquito, or when I'm overloading my system with antibiotics because I happened to host a tick smaller than a pin-head, or when I'm sustaining a series of injections in my belly so I don't start foaming at the mouth myself? Lathered with bug spray and sunscreen and would you believe it? – a bulletproof vest – how close am I to nature now? Whatever purity I thought I could participate in via fresh air and fertile soil, in communion with all manner of animals, vegetables, and minerals, is now irrevocably tainted.

At the age of fifty-three I think I can finally, genuinely, say I am living life to the fullest, but not in any wholesome, hokey sense of the cliché. I used to think living meant being outdoors, intimate with the Earth: I set up my easel in forests, up mountain-sides, on beaches, you name it, no glass screening me from natural light and the Earth's true colors – all the while renting a studio I didn't paint in and fearing eviction since I'm not supposed to be sleeping there! At last I've solved the dualism. Now I barely leave the studio. Now art is my oxygen, my nutrition. I breathe it and bathe in it, I tossed out my protective masks, I suck in the fumes with gusto, stir my coffee with the wooden stick that mixes my paints. Yesterday, I decided I'd borrow a blue period from Picasso, and I painted myself, head to toe – a much more original version of blue balls! All this fear of toxicity from fixatives, fumes, glazes, etc. I've had it with the whining women who bemoan premature deaths from the heavy-duty

toxic substances they encounter in their work; they should tackle mother nature and compare the results.

Nothing horrified me more than the radical deed of my sister-in-law, who lopped off a breast prophylactically because she'd screened positive for heavy-duty cancer genes. Must fear dictate our every move? Are we so thoroughly enslaved to the inevitable that we must mutilate ourselves to be, theoretically, better armored? No thanks, not me; I'm inverting prophylaxis: I'm heading straight into the eye of the storm, and I'll lick fear that way. In fact, I lick my favorite surfaces – freshly painted ones – because it helps me engage more intimately with my art.

I'll take my niece's route over my sister-in-law's; she's preparing for the apocalypse by drinking a ton of soda and junk food heaped with food additives and preservatives. A pure body will perish instantly, she told me, and she's got a point there. I don't know why I didn't think of it sooner. I'll bolster my immunity through poison, and fate won't dare sever me from my art. What artist has a healthy life-style anyway? Boozing and snorting and shooting up and all the shit we're famous for: isn't it time someone took it to less monotonous extremes? "He lived and breathed art," they'll say about me (instead of "Poor wimp, he was ravaged by nature!"), and it won't be some prissy, sissy metaphor. The way mathematicians exult in the purity of a theorem, I revel in my new-found freedom from boundary, from constraint, from fear. Just like adapting to the atmosphere of another planet, my body will mutate to accommodate this new environment.

Already I feel liberated, energized, far more so than from some acupuncture pinch or shiatsu pressure. Green tea indeed! I'll have blue tea, red tea, purple tea! Who needs those goddamn antioxidants? Food will soon enough be nothing but engineering anyhow. Why eat Monsanto's veggies when I can give up all pretense of purity and capitulate with gusto? Breathe polluted air and who cares? I'm fortified with toxins. Being one with nature didn't pan out so now I'm one with synthetics and chemicals: ingesting, imbibing, inhaling. And I've had visitors streaming in to observe my work-in-progress installation. Watching a grown man streak through his studio coated in acrylic or oil! Watching a grown man eat clay. Joining in a non-wimp's aromatherapy: bring on the fumes! My reckless life on display. What do you say? Could I be officially designated artist-in-extremis?

Sincerely,

Easel Kinevil

Dear Euphoric-for-the-moment:

Let me preface my remarks with a warning: this had better not be some elaborate publicity stunt. As it's my policy to assume sincerity until proven otherwise, I won't make your letter an exception.

Given that your (Earth) Mother has abused you and you desperately need some maternal common sense, I'll certainly give you the time of day, and some compassion to boot, even if my tone may appear less than indulgent. I'm not the surrogate-mother type, but I am concerned about you, as well as the relatives you mention and others I presume exist, though you haven't mentioned them. The man on the street or the corner

druggist could tell that you're off your rocker, *as they used to say; you don't need any artistic – or for that matter, clinical – expertise to issue that diagnosis/warning. A little Prozac (or one of its relatives) might go a long way toward assuaging your agony-cum-euphoria, and gently – but if you think puking your brains out from encephalitis was bad, try Taxol! I don't think chemotherapy will be any improvement! Certainly no respite.*

I wonder, are you reverting to childhood so as to make an ostensibly indifferent mother nature pay attention? To a six-year-old's tactics? Hey, Ma, I'm eating the whole container of Playdough! (They make it non-toxic for a reason.) And if you were lucky enough not to be one of those kids exposed to lead paint when growing up, isn't it perverse to reverse that? Lots of those kids would have wanted a choice. Do you think you're getting even with nature by inflicting even more damage on your body through synthetic means, out-smarting her, out-hurting, out-machoing Big Mama? Like weenie-wagging – mine's bigger? She hasn't got one; she doesn't need a dick! What sort of anthropomorphic delusions are these? She's not listening! She's got a huge brood, and she'll waste no remorse on your sorry ass. (And I'm a sorry aunt, for having to be so blunt.)

Great that you're at last making use of the studio and all, but is it worth it? I mean, rent's even cheaper when you're dead, you know. Don't turn yourself into a still life (through rigor mortis)! Indeed, watching someone die has, to my knowledge, not yet turned into performance art, but having seen a few individuals pass from this world, I don't care to degrade it into spectacle, even slo-mo as yours might be. (I do know someone who once staged a rape as performance art, but I walked out of that show as soon as I realized what was

happening.) Cut your losses, I'd say, and risk producing a few insipid still-lifes, because duuuhhh – all those visitors are likely to call attention to your transgression, and even if you are getting more use out of your studio in a nine-to-five manner, you're still an official squatter every time you snooze, so be prepared for your landlord to be one of the visitors soon, and don't expect him to ooh and ahh as he hands you notice, but no matter – by then it might be straight to hospice. Have I made myself clear, Mr. Easel Kinevil?

Look, making art's not a walk in the park, I'm the first to admit; making a living from it, even less so. And it sounds like a nice walk would have been considerably less deleterious than the field trips you took over and over in the interest of being true to your vision. But you don't have to renounce those ideals just because you've suffered for them, right? That's my piety for the day, now back to pragmatics.

The art world already has its share of stunt men – keep trying to make it to posterity with integrity, rather than with hype. Every profession has its hazards. I travel constantly for my art; it wears me out. That doesn't mean I get some demented scheme to live on a plane and make every 747 an installation. And no pilot would either! You don't see coal miners putting their heads together down under and deciding, hey, why bother to come up? – instead we'll become the black lung species, after a few evolutionary eras – gee, what pioneers!

OK, you may be, relatively speaking, original, but what is the point of being an original imbecile? You don't want to confuse embrace of art with a death wish! If I've wounded your pride and burst your euphoric bubble, it's only because I want you to snap out of it so as to forestall eternal agony! I could much more easily say, "Let them eat clay," you know?

Easel Kinevil

But I'm trying to do a good deed here. Dust off those landscapes for the posthumous show, or stop inhaling the dust in your studio. Remember the lesson your original mother must have taught you in your earliest years: watch what you put in your mouth! My guess is that you still need some wet nurse's nurture, but don't look to me. I've already discharged my obligation by offering counsel. Do me the courtesy of heeding it.

Just as sincerely,

Gina

DEAR **G**INA: Here's the thing: we were in Rotterdam for yet another one of my husband's bit parts in a king-size group show with a clunky title. I try to stay as far away as possible from the flirt-fest blood sport known in some quaint circles as "the installation period," but it was day three alone in this alien city, and with the leisure time for vague jealousies to fester, I knew I had to show my wifely mug. I casually dropped in at the RAC (Rotterdam Art Center). Before I'd even said a word, Gabe said, "Let's go." Ferrying me away so quickly made me immediately suspicious, but all paranoia melted when I saw the shop: I was thrilled. He was thinking of me after all.

Gabe asked the salesman at the counter, a guy that even his fellow Dutchmen would call tall, if the vibrator he had picked out would run all day. There was a long pause. I backed away from the counter pretending that the lubricant samples across the aisle had caught my attention, hoping I could somehow disappear into a jar of SuperSilky. The towering Dutchman looked like he owned the place and had heard every possible question about sex toys, yet he was acting as if Gabe had posed a question he'd never heard before.

I'm not sure why Gabe picked the slightly crooked rubber penis model out of the hundreds of choices in the shop. The ones that looked like they were made out of Murano glass were the ones that appealed to me. They were translucent, ocean-colored, and cool to the touch. I imagined making a trip to Italy to have one handmade especially for me. I imagined opening the

dishwasher right after the drying cycle ends, grabbing the warm glass dildo, and like hot fudge on a sundae, using it before it cooled down. I imagined it glistening on the windowsill.

Gabe hadn't asked my opinion about the dildo, which was strange, since he was obviously buying it for me. He didn't really say much at all as he intently examined dozens and dozens of models. There was a clear preference for the soft ones. He didn't fondle them, he didn't examine them like pieces of fruit: he simply squeezed them between thumb and forefinger as if the inside was what really mattered. I think it was at about this time that I began to think that my husband was being rather perverse, not because of the way he was examining the dildos and vibrators, but because he had taken me along on this trip to buy me a present and wasn't conferring with me. This was a guy who had never made an independent decision about a present for me in his life. He was clearly displaying his passive-aggressive signals, his non-verbal way of saying, leave me alone – I'm trying to figure something out.

I know it sounds like I was standing in this store trying to spy discreetly on him while waffling between being baffled by his behavior and wondering why he was so focused on the most unappetizing dildos in the place. But really, that only lasted a second, or at least only until he asked if the vibrator would run all day without changing batteries. Now – and this is the main thing – I'm getting turned on by this tease he's doing. I'm thinking how masterful of him to make the very act of buying the vibrator a tease in itself. I'm trying to

imagine how each vibrator and dildo he examines might feel when I use it. But it's hard because, as I said, I'd already fallen for the translucent blue Muranos. I'm thinking, how brilliant! This won't be just a vibrator, but a vibrator forever associated with this weird private performance in public. I'm thinking, how sweet: he's installing his work at the RAC and he knows I'm totally at the mercy of his schedule, and there's a lot of down time for me and so he's buying me a present, one I can get some pleasure from in the morning after he's run off to work on his installation, and I'm in bed watching CNN.

I'd tell you about the kind of work he makes, but I'm afraid you might know who he is and it would prejudice your advice. I know from your column you make tracks in the art world. I've been to lots of openings where I'd see a woman and so hope she would be you. It even happened at my own opening. It was fabulous. It completely took my mind off noticing which friends hadn't come and the fucking lame excuses I'd have to hear for the next two weeks. Who cares, I thought, Gina's here.

Anyway, Gabe finally settles on this rubber one that looks like it's been disengaged from a giant doll. Maybe that's why I immediately gave it a name – GI Joe. Gabe pays, I daintily remove the excess lube from my hands, and we start to walk back toward the hotel and the RAC. Gabe seems really keyed up, and all I can think about is whether he's fantasizing about me, GI Joe, and CNN, or me, GI Joe, and himself.

On the way back to the RAC, we pass through Rotterdam's giant Saturday open-air market, which always

makes me want to browse. Gabe is too anxious to slow down the pace to look, but he's willing to stop to have *patat* (fries). He always wants to share one; I always want my own. As usual, he promises that he doesn't want very many, which he sincerely believes, but I know it won't turn out that way. We get an order with ketchup on one side and mayo on the other. I'll let you guess which side I prefer. We skip the peanut sauce. Peanuts here have too many associations with Dutch colonialism. No, that's not the real reason. It's really the peanut-potato combo that I can't grasp. In any case, we sit down to eat our *patat* in their paper cone and I'm in a mild panic about getting as many as I want without eating too fast, but fast enough so the spuds don't get cold and he doesn't eat more than me, all the while still thinking about that mysterious performance.

Then, just as my reverie is peaking, we see strolling toward us a famous artist whom we've met on numerous occasions. He's one of those older male artists whose behavior, I'm sure, has resulted in many young female artists writing you letters for advice. You know that pleasure-loving famous male artist type. Anyway, he and his young friend spot us and join us. After the usual pleasantries and inquiries, Gabe says his show is almost installed, save one technical problem for which he thinks he now has the solution. I wish Gabe would follow his own advice: if you have to plug the work into the wall there's always a problem. It's probably not even necessary to say it, but of course, it's almost always boys who need to plug it in.

Famous delves further into Gabe's technical problem, but really as a way of talking about himself rather

than addressing the issue at hand. He's not even giving Gabe a chance to explain how he may have solved the problem. Famous's galpal says she's going to look for a belt in the flea market and do I want to come? Those were the words she used: do you want to come. Maybe she saw the vibrator box in Gabe's shopping bag. Maybe she had a sex sense and thus knew what I was thinking about. I liked her immediately. I liked her even more when she told me she had heard enough Famous stories for the day. I told her about my recent visit to "Fokker 69" and I wondered out loud how I was going to tell Gabe that I appreciated his concern, but GI Joe just wasn't for me. I knew it was going to be hard. Gabe would be hurt that I didn't fully appreciate his gesture, and I would have to resist getting angry that he was acting hurt and making me the bad guy. In fact, I knew I would get angry and tell him that what really upset me was his incredibly bad judgment. Then the ammo would just start exploding. I would go on to mention another half dozen examples, exaggerating them as necessary, in order to prove how clueless he was about my desires.

Galpal picked out a belt and wrapped it around her she-can-wear-anything body. We headed back to the white metal table and chairs where we had left the boys.

We turn the corner, and we're maybe 100 feet away when we spot them. It looks like they're having a tug-of-war with something. Or really, it's more like Famous is holding on to something, squeezing it tight while sitting in a chair and bracing his feet against the ground, and Gabe is standing about four feet away

pulling on wires attached to whatever Famous is holding. Then, as we approach . . . snap! Famous's chair flips backwards. Gabe goes flying backwards and bounces off a chain link fence. Famous is lying on his back, still sitting in the chair, laughing and holding GI Joe up in the air. Gabe is holding GI Joe's battery pack still attached to the wires that are still attached to the black cylinder that they had managed to pull out of GI Joe. Galpal helps Famous get up. Gabe puts the black cylinder on the white metal table and pushes the on button on the battery pack. The black cylinder starts to vibrate, causing the top of the table to vibrate. Gabe says, "I knew it would work. Now, all I have to do is put this inside *Quake,* glue the cylinder to the wall, and it will shake. I knew there was a way I could avoid plugging it in. The wire from the work to the wall would have stolen all of the mystery."

Gina, I was completely deflated. He hadn't been thinking of me at all! Once again, his work trumps the relationship. When is enough enough? Gina, I'm relying on your insight to help me here.

A true fan,

Rose

Dear Thorny Rose:

Has anyone ever told you that your fantasies are hyperactively unhealthy? Hence the jealousy, the paranoia, the self-delusion, the shocking inability to tell when your boy's mind is not *on your no doubt irresistibly seductive body. Forgive me, but nothing depresses me so much as a woman who hasn't learned the score. You* are *a woman artist, right? Fierce, independent, pleasure seeking, not in thrall to the phallus.*

Grow up, girl! You're suffering from the imperial affliction that I thought we women had shaken off thirty years ago! I had never thought of myself as a thin-lipped feminist, but doing this column has really opened my eyes.

Okay, end of rant. Guidance is what you want. So let's take a closer look at your tale of Rotterdam woe. First mistake: tagging along. What were you even doing there? *Didn't you have something better to do than wait around all day for your guy to pay attention to you? Why go all the way to cold, damp Rotterdam to keep him company, especially if he's there for one of those monstrously overpopulated group shows that remind me of cattle slobbering at the trough. And – on top of everything – you forget to bring your* own *Rabbit Habit? You put yourself in this position, honey. I know, I know, it isn't right to blame the victim, but never forget Gina's first rule for artist-artist coupledom: thou shalt not tag along. Now, if you have some legitimate reason that overlaps and pop over for a few delicious conjugal furloughs, culminating with a whopper visit that coincides with his opening. And by all means, bring along a toy of your own. Don't wait for him to gift you a schlong of glass (personally, I prefer surgical-grade stainless steel); make your own move and watch his eyes widen at the sight of you handling a device beyond his wildest dreams. You'll be amazed by what happens to his own.*

Second mistake: the silence of the lamb. You're in the sex toy shop, right? He's shopping for dildos and you're weirded out because he doesn't consult you, the supposed benefactress of his largesse. What in god's name are you waiting for? You want a G-spotter! *Or, if you're feeling generous, in a sharing mood, ask for a double-header (yes, girl-boy combos work too – use your hyperactive imagination). Open your mouth and*

*tell him. Simple as that. God, sometimes I just don't get it.
What does it take for a woman to learn to express her desires?
Sorry, Rose, I know this is hard to take, but I've always been
a big fan of tough love. It's why I jumped at this column when
they asked if I was interested. I just love doling out the busi-
ness. But back to you: don't be shy –* don't ever be shy!–
*about telling him (whoever he is: husband, lover, bore) what
you want. They're not as smart as you think, dear.* We're the
*ones who can read minds, remember? Unfortunately, we have
to plan for us and them: always have, always will. It's an-
noying, I know, but a woman forgets this maxim at her peril,*
especially when it comes to sex. *Got it?*

*Okay, now we're getting somewhere. Ready for Gina's
probing analysis of your psychosexual hang-ups? I hope so:
this is what I get paid for. Besides, you really asked for it,
Rose.* "I'm getting turned on by this tease he's doing."
*This, you say, is the "main thing." Well, I can't argue with
you there; this does indeed seem to be the main thing, but I
don't think the thing you're thinking of is the thing itself, if
that makes any sense. For the moment, let's put aside the fact
that you were dead wrong: he wasn't teasing you – he was
utterly oblivious to your existence, as it finally dawned on you
only after the manly display of dildo-busting you so charm-
ingly describe. So, suppose he was in fact buying you a vibrat-
ing dil before your very eyes without breathing a word to you
about it, seeming to plan your pleasure but keeping you in the
dark so that you're just all expectation, waiting for the mas-
ter (that's* your *word, honey: "How masterful of him"!) to
administer his "brilliant" touch. Can't you see what's going
on here? You're suffering, my dear, from an incapacitating
mixture of subservience and denial. Your little fantasy in the
sex shop shows that not only do you want to be teased,* you

21

want to be mastered, *and as any masochist will tell you, enough is* never *enough. Now, masochism itself is nothing to be ashamed of, especially in our line of work. But when you're clueless about your own desire to be mastered, you're in for trouble.*

The weirdest part of your letter is when you fret about the prospect of getting angry with your husband for not understanding your desires. Come again? Talk about denial! Trust your instincts, honey! Of course he's clueless about your desires! If buying a vibrating dildo in your presence doesn't generate even a hint of curiosity in Gabe about what's going through your head, then yes, we've clearly got a clueless one on our hands. Here's where I couldn't agree with you more: I don't care how obsessed a guy is with completing his installation, if you're there with him, there should always be something in the air, even if both of you just take a whiff every once in a while.

Now, I know I haven't even touched that priceless patat *story (Afraid he'll eat more, eh? Wonder what that could mean . . . ?), but I think you can figure that one out for yourself. Face it, Rose: you're a masochist. Your marriage sounds just fine, really. All you need to do is fess up and tell ole Gabe, loud and clear, when you want to feel the heel of his boot. Sylvia Plath was wrong: every woman does* not *adore a fascist – but you do!*
Warmly,
Gina

P.S. I'll see you at your next opening. I'll be the one with my own french fries.

DEAR **G**INA: One of the adventures you shared in *Naked Came the* **** hit uncomfortably close to home. Like you, I seem to be embroiled in a potentially harmful relationship. As I became increasingly absorbed in the narrative, I couldn't help but feel that your lover in Queens is a pompous, egomaniacal, and pretentious jerk. He deliberately messed up your installation, humiliated you in public, and then, instead of staying with you, cuddling you, and sharing your post-orgasmic afterglow, he took off. It sounds to me like he left with a younger woman who is not even in the art world. I know I would not stand for that kind of treatment.

Here's where the eerie parallels begin. Like you, I'm an artist, primarily involved in the creation of conceptually-oriented, site-specific performance pieces. Like your fly-by-night lover in LIE, my long-term lover is a writer. Nothing wrong with that, except that he began to claim, not so very long ago and to anyone who will listen, that he is an artist. In fact, he began bandying it about that he's on the same level as me, at least as far as art is concerned. That's where he went too far. I feel I have to stand up for myself, for my art, and for the reputation of art in general and particularly art by women.

I have a lot of respect for your work, Gina. And for you as a person. I hope I didn't sound judgmental in my assessment of your writer-lover and your interactions with him. Your personal life is your personal life. And my personal life is my personal life. Which

brings me around to the problem that my writer-lover and I are living through at the present time.

My lover is having an affair.

Notice how I say he "is" having an affair, not that I "suspect" he's having one. He is. I have proof.

I envy your free and easy attitude as far as your lovers are concerned, Gina. I almost envy your obvious fear of commitment. I, however, take my relationships seriously. I hold them on a par with the art I create. Which is why I feel I need your help in this dilemma. Your *"laissez-affaire"* attitude might be the breath of fresh air I need.

It all began when my lover got caught up in a critical obsession. I mean critical in the sense that he is a freelance art critic. Part of the reason for our initial mutual attraction and courtship was that he told me he writes an art column. He told me that he wanted to be closer to the creative process, so when he asked if he could move in with me, I said yes. I don't believe it's such a bad thing to look for a little publicity where you can get it. Not just for me, but for women artists as a group. I have a feeling you aren't having sex for your own personal fulfillment 100 percent of the time, Gina. Am I right?

As it turned out, the "art column" my lover writes is for the pages of a notoriously exploitive men's sex magazine. He knows how strongly I disapprove of this, but it does pay his share of the cable bills in my loft/studio. I kept hoping my lover would surprise me with a review. The words of Andy Warhol played over and over in my head: "There's no such thing as bad publicity." That was before I actually

read his "column" and found out it's not about art at all, it's about XXX-rated porn videos.

I know video art has made strong headway lately, but how can my lover realistically claim that such filth falls under the category of art? And that he is an artist for giving justification to split-beaver garbage in print?

If that weren't bad enough, he explained his recent long periods of absence by admitting that he was conducting a series of in-depth interviews with his favorite porn star, who is, he says, "quite an artist."

Sometimes I wish I were as free-and-easy, as swing-positive as you are, Gina, but I have principles. I have ethics and morals. I believe certain things are wrong. I'm not a prude and I don't approve of spying on people, but when my lover failed to show up at the *vernissage* of my last show, it was the last straw. I am, as I've stated, a conceptualist, with a gallery, quite well-known. I mean, the gallery and I are both well-known. My opening was the start-off for the season. Everyone was there – everyone except my lover. His failure to attend the event hurt me badly.

At first, I chalked his non-attendance up to creative professional jealousy. My lover's novel has not yet found a publisher. It's what you might call "racy" stuff. I wanted to be understanding about this, but when I got home and found him in front of the TV watching you-know-what, I confronted him about his conspicuous absence. I was angry, and I admit I had drunk a tad too much *vino bianco*. Imagine my rage when he honestly didn't have any idea what I was talking about. He'd forgotten about my opening entirely. The reason he gave was that he had spent the

afternoon and most of the evening conducting another interview with you-know-who.

In case you don't know who, I mean a certain young lady who spreads her legs for a living. I don't want to stoop to naming names, but since "Lillian Gash" is her porno alias and not the one she was baptized with, I'm OK with it.

In my mind, I put 2 and 2 together and got 4-nication. But there was another part of me that had to be sure.

After a week of contrite, exemplary behavior on his part, we were eating take-out in front of the TV one night when his cell phone buzzed. He got up and left the media area, so I immediately knew who it was. He must have thought I couldn't hear him, but I'm sharp that way. He said, "Yeah. Sure. Tomorrow's going to be OK. We can do it here again. She's got a meeting with some German guy."

Actually, my meeting was with a collector from Zurich, but I let it slide.

Early the next morning, while he was still snoring, I got on my own cell and cancelled that appointment. It probably cost me a five-figure commission, but wait till you hear what happened. I left a note in the breakfast area that I was meeting the collector in Connecticut and would be back late. I implied that I might even be spending the night. I hid under the kitchen sink, an area he never approaches. More importantly, it is a site with clear, unobstructed sight lines to the bedroom area.

It was not exactly cozy in there, but compared to my "Chained to a Fire Hydrant" and "Naked Mole

Person" pieces, this domestic stake-out was a breeze. In my hands was the compact, utterly silent digital video camera that the Holmes Endowment for the Arts laid on me for their New Projects series. I wanted more than tear-stained hankies and a broken heart as evidence of my lover's betrayal.

He slept until noon. I checked. The professional porno slut knocked on the door at twelve-fifteen. She wasn't alone, Gina. She had brought a film crew with her. You should have seen what they were wearing.

What my lover was wearing was my silk kimono. He looked so sexy in it too – so macho-lipstick – that it made my heart ache. He'd "forgotten" to tie the sash, so guess which part of him was front and center to greet his porn star gal-pal.

She spent an hour getting into make-up. Puh-leeeeeze. Then they get on the bed . . . our bed . . . my bed! My lover starts telling this XXX-rated slut Lillian Gash all about the scene they're going to film. He's also telling the cameraman and the soundman and the guy who holds the microphone on a boom and the lighting director what to do.

Not only is the creep cheating on me, he's renting out my loft space to film fuck flicks. He's also the director. And the male lead.

Needless to say, I was documenting the whole thing, directing my own "Heart of Darkness" to his "Apocalypse Now" while my heart was breaking.

Do you know what a Mexican Cartwheel is, Gina? Have you ever played a game of Anal Chicken? I have a feeling you do, and that you probably have, but I most certainly had never even imagined such

things were possible. The hurt was compounded by the fact that my lover had never displayed such prowess and creativity in bed with me. Grudgingly, I have to admit I was impressed. My lover is some kind of artist after all. While I had at least one finger on the "record" button the whole time, the other digits strayed, I confess. I learned something about myself under that kitchen sink, not just the truth about my cheating lover-man.

What have I got here, Gina? Alternative fem-porn? Video art? A new format for Reality TV? Do I call Sally Jesse, the Guggenheim, or Larry Flynt? The only thing I know for sure is, I've got a bad case of the woman artist blues. Help!
Body of Evidence

Dear Body of Evidence:

No wonder nobody likes us successful women artists. No wonder there's never been a Picasso with a pussy. We want to be artists and *women. We want money and publicity* and *meaningful relationships.*

Listen to you: "I'm famous! My gallery's famous! My boyfriend must be jealous of my career! He never plays Anal Chicken with me! The slut spends an hour putting on make-up (hope it's sperm-proof)! Gina, I respect your work! Gina, you have no morals!"

You presume to be offended – now there's a concept I hate – by the fact that my lover "messed up" my installation at the Queens Museum. I was delighted, in the end. He made me see my piece in a whole new way. What happened turned out to be a collaboration – ever heard of that? Is that a concept you can grasp?

Instead of using the opportunity to collaborate in your lover's movie, you remain in hiding under the sink, silently masturbating while voyeuristically recording every stroke and orgasmic shriek. You claim to feel so hurt, so put-upon and "offended" by your lover's "betrayal," yet you can't wait to whore it (and yourself) out to the highest bidder, knowing full well you've got a red-hot bestseller on your hands. But even that's not enough for you. You want my readers to know all about it, too.

You say you respect my work. What crap! I've got more respect for Lillian Gash's work. At least when she chains her nude body to a hydrant, she's not doing it for anything more pretentious than cash. You tunneled through mud and manure in your birthday suit for the NEA, not for Art with a capital A.

If Lillian is conscientious about her makeup, it's for the pleasure of her viewers, not vanity. She once told me, "You know, it's all about light. I mean, I'll be through with this $500 by Friday, but the light that bounced off us today is going to cause thousands of guys, maybe millions, maybe some women too, to masturbate and jack off and be happy for years." She wasn't spraining her fingers trying to get Krens or Lowry on her speed-dialer because she'd just wrapped a boner epic.

Instead of being down on a woman who "spreads her legs for a living," why don't you try going down for a living? See if anyone pays, or jerks off. Emerge from your hiding-place under the sink, that symbol of female oppression. Turn the camera on yourself. Do you like what you see?

I know I'm sounding rather harsh here, Body of Evidence. We women can be our own worst enemies at times; we womyn artists worst of all, perhaps. We need to help each

other, heal each other, and hold each other. I enjoyed your Naked Mole Person piece. Oh yes, I know who you are, Body of Evidence. The art world is a small world, after all. We should try collaborating. What's your writer-director-lover's phone number? Oh, wait . . . I already have it . . . on my speed-dialer.

Gina

KIMBERLY

DEAR **G**INA: My name is Kimberly (not my real name!) and I am a sophomore at a prestigious East Coast liberal arts college (hint: we share an alma mater!). I just turned eighteen (I graduated a year early from high school, so I am by far the youngest in my class!) and had a life-changing experience that I wanted to share with you.

Last Friday (the day before my eighteenth birthday!), Professor X (not his real name!), my very handsome, distinguished, older, life-drawing class professor, asked me to stay after class. I had heard rumors about "dangerous liaisons" with a few of his favorite students, and his salt and pepper hair and neatly trimmed white beard are really sexy, so my heart was really pounding!

When we were finally alone, he said, "Tomorrow is your eighteenth birthday, the most significant passage in a young woman's life. I'd like to share the event with you, guide you through." He looked at me penetratingly. "I can see you're ready." I must have turned every shade of red in the Pantone book, because I felt all hot, especially down below. I was even worried I'd wet myself, but I checked my jeans later and they were dry (on the outside anyway!). He gave me his address (as if I hadn't looked it up after the first day of class!) and told me to be there at six p.m. the next day.

I could barely sleep that night, I was so excited. I couldn't stop fantasizing about what he really meant about guiding me through the "significant passage" of my eighteenth birthday. Did he know I was still a virgin

and want to deflower me (hope, hope!)? And how did he know it was my birthday anyway unless he'd looked me up like I'd looked *him* up, which meant we were on the same wavelength, which was a *really* good sign!

Anyway, the next day, by the time I was finally ready, I had tried on every outfit in my closet and picked the "Chelsea" look (like the art gallery neighborhood in New York, you probably know about it!), because it was all black, to show Professor X that I am serious about art, and a little bohemian, too, so he'd know that I'm willing to have fun and explore new ideas. Well boy, oh boy did I explore some new ideas! I got to his house, which is deep in the woods and very private, right at six, and I knew it would be nice because Professor X is such a terrific dresser, but wow – what great taste! Totally masculine, with a huge blaze roaring in the totally classic, round fire pit, tons of really cool art (including some female nudes – foreshadow!) and he even had a camera and tripod (and video camera, too!) set up and ready to go. It was clearly the home of a serious artist.

I looked over at the galley kitchen and didn't see anything on the stove, so I thought maybe we were going out to dinner. Then I noticed a package of those "foot-long" hot dogs by the fireplace, but I was pretty sure that Professor X hadn't invited me over for a weenie roast! I heard a cork pop and Professor X told me to sit in one of his iconic chairs while he poured us some red wine (he called it a "serious burgundy"!). He looked at me very intensely (melt, melt!) and raised his glass.

"Tonight, I'm going to teach you what you could never learn in a classroom. I've been watching you. You're an excellent student, a hard worker, but it takes much more than that to be an artist."

He took another sip, then leaned forward. "Your work will only become *art* once it reflects the raw, naked essence that is *you*. And to find that essence, you have to shed your fears and inhibitions – by exposing and debasing yourself. You can't be strong until you've been vulnerable. Tonight, you're going to learn that lesson thoroughly."

I felt that hot, wet feeling again as he leaned back and put his glass down. "The lesson begins now. Open your blouse." I tried to obey his instructions, but my fingers were weak and clumsy.

Professor X sat up straight, and his voice got very stern. "I'm going out on an academic limb for you because I believe in your potential and I know you're ready to learn what I have to teach you. Don't fight me: I'm the professor. I know what you need. Right now you need to do what I tell you – *or you'll never become an artist!*"

When I finally realized what a serious sacrifice Professor X was making for me, my girlish fears vanished. My blouse was off in no time, and there I was in his designer armchair, totally topless (no way was I going to wear a bra that night!), but instead of feeling embarrassed, I felt totally empowered, and most of all proud of myself for not disappointing Professor X.

"Now the skirt," said Professor X.

I started to gather up the hem of my long skirt when I realized that I had forgotten to wear underwear!

Was that a Freudian slip or what? But somehow that realization emboldened me, and I don't know what came over me, but I yanked the skirt up to my waist, spread my legs as wide as I could, and hooked a knee over each arm of the chair so Professor X could see absolutely *everything!* I thought I saw a subtle smile on his lips, but he just kept staring into my eyes, even though I could tell I was getting all wet and swollen down there. I arched my back and pushed myself towards him so he could see even better. I wanted him to look at me, dammit!

"Good," was all he said, then he got up and dragged a chrome and cowhide Corbusier lounger over to the fireplace and instructed me to get on it. "Leave the skirt on," he commanded. I obeyed, of course, and climbed aboard on all fours. Once I was kneeling on the highest part of the lounger (the part where the *backs* of your knees usually go, not the *fronts*, like now!) he told me to stop there, with my head and hands facing down so my butt was way up in the air. Then he came over and threw my skirt over my head!

I sure hadn't expected to celebrate my birthday like this! I felt so exposed and dirty with my skirt covering my head and everything else naked in the air, but it was nice and cozy under there, and the fire from the circular pit was keeping the rest of me warm. I wanted to feel as debased as possible, to really learn what Professor X was trying to teach me, so I inched my knees as far apart as they could go and pushed my butt up as far as it would go and waited to see what would happen next. I heard some funny noises, things

being moved around behind me, some weird clicking, even some crinkling plastic.

As I waited for him to continue the lesson, I felt myself waving my spread, naked underside in the air like an antenna seeking a signal. Then I heard myself start to moan. I waved around a little harder, and moaned a little louder, but Professor X just kept making all those weird noises. I was dying to know what he was doing, but I didn't even *think* of peeking. Professor X had pulled my skirt over my head, and that was where it was going to stay! I just wanted *something* to happen! I was eighteen now, totally legal, and totally ready. I was trembling on the brink of transformation, about to become a woman, and an artist.

Suddenly, I felt him at my side. "It's so much better that you're a virgin: the lesson will be much more powerful for you."

Could he really tell just by looking? And if he was looking, why wasn't he touching? Was there something wrong with my genitalia?

I was aching with anticipation as the crinkling noises began again, and then my moans turned to a gasp. I felt his penis slide right into my vagina, and it was amazing: not painful at all, like the dorm girls said. But it was weird, too, because it was so wet and thin and lukewarm. Definitely not what I had expected. Then it was out, then it was back in again – only now there was another one in my butt! I didn't know what was happening, but I was squirming and moaning because it felt *fantastic!*

I heard the crinkling again, and suddenly I knew what the sound was: it was the package of hot dogs I

had seen by the fire pit. We *were* having a weenie roast after all, but not for kids – this one was for adults only!

Professor X slid both of the weenies in and out, then a weird poking "in front" told me that he was putting in another one! I couldn't believe it – in less than an hour I had gone from *slightly* prudish virgin to wanton woman being doubly (triply!) penetrated in the crudest, lewdest way possible! It still shocks me to admit it, but instead of feeling debased like I was supposed to, I *loved* it! I loved being so dirty, I loved the sex sounds I was making under my skirt, but most of all, I loved that my mentor Professor X was giving me this incredible and valuable experience. I wasn't totally sure yet what it had to do with being an artist, but I knew I had to go through it in order to become one. I made up my mind right then and there to be as dirty as possible so I would truly feel debased and learn what Professor X wanted to teach me.

The hot dogs stopped twisting and sliding around, and I heard a clicking sound, then they moved again, then there was another click. Suddenly, I knew what *that* sound was – Professor X was taking pictures of me and the weenies! I was not only becoming an artist, I was becoming *art*! I was helping Professor X as much as he was helping me! We were collaborating!

"More weenies!" I panted from under my sex tent. If it was true what I'd heard about his other "special projects," I wanted ours to be the *best!*

"Hold still a moment," he directed, and I did my best not to wiggle around like crazy while he worked

in two more, one in front, one in back. That felt even better, five altogether, but I knew I could do better. Of course, I waited patiently and posed very provocatively while Professor X took more pictures, then I shook my butt to show I wanted more.

Professor X was totally impressed, because he said I was a really fast learner and that his instincts about me were right. So I wiggled harder, and the ends of the foot-long hot dogs slapped against my butt cheeks in a way that I knew would look great on the video!

"Try to relax, Kimberly," he said, and I tried, but the sound of his voice saying my name, plus the crinkling that promised more penetration, was driving me so crazy I thought I was going to explode! I forced myself to relax so he could squeeze in the last three hot dogs.

He started in the back and got another one in after lots of twisting and turning. It was awesome knowing I could hold so much (especially the very first time!) and also finding out that "anal penetration" was so incredibly stimulating. I pitied those dorm girls with their dopey, college-age boyfriends – they had no idea what they were missing!

Anyway, we were up to six (three in front, three in back, in case you've lost count!), and I really hoped I could fit in two more. (I figured the package contained eight total, and I was right!) Professor X took some more pictures, then I heard that crinkling again and he was doing his best to work another one in up front. I relaxed my "special muscles" again, and pushed myself up against the poking tip of the weenie to help

him as much as I could. Finally it was in and I was trembling and panting because it felt so unbelievably good!

"Please . . ." I begged him, "I need more. . . ."

"Be patient," he instructed me, his camera clicking while my whole lower body shook and shuddered. "Savor every sensation. Make it last."

His authoritative voice brought me back to earth and I made myself focus on the work, even though it was hard not to think about where he was going to put that last hot dog! The wrapper crinkled again, and I whimpered, "More, more. . . ." because I was really aching for it now.

"Not so fast," he told me, gently this time, and instead of forcing it in, he used the last hot dog to rub what I realized had to be my clitoris. (Can you believe how naïve I was?)

All of a sudden it was like my lower body had taken on a life of its own. My hips began to rock faster and faster in rhythm with the sliding weenie, and my groans turned into screams of ecstasy unlike any sound I'd ever heard (or made!). He kept rubbing until my throbbing clitoris exploded like a supernova and I was screaming and shaking, and the hot dogs were thrashing back and forth like palm trees in a hurricane and then one super-huge orgasm made all seven of them shoot out sky-high all over the room!

Even with the hot dogs gone, Professor X kept on rubbing my quivering clitoris with the weenie and I kept on coming and coming until I finally collapsed in a trembling heap on the lounger. I lay there for a long time, thanking my lucky stars that I hadn't gone

"all the way" with anyone else. How pathetic *that* would have been! (And it certainly wouldn't have done anything for my career!)

The rest of the night was a little disappointing: not very romantic, considering what we'd just done, but Professor X was very polite and even showed me the video, and said he hoped we'd be able to collaborate again "very soon." Then he dropped me off at the campus shuttle stop near his house (he's very discreet!) and I went home, knowing I was a new woman, and most of all, an artist.

But now, as I sit here at my desk, five days later, anxiously awaiting tomorrow's life-drawing class so I can show Professor X how well he taught me, I can't help asking myself the "big question": am I still a virgin? Do hot dogs count? I know this sounds totally naïve coming from someone like me, but I just don't know, and you're the only person I can ask. Please write back ASAP!

Thanks,

"Kimberly"

Dear "Kimberly:"

So "Professor X" is still at it. The dirty bastard owes me royalties from our *"special project" (your charmingly circumspect words again), but more about that after I address your dilemma.*

And the answer is: I don't know if you're a virgin or not. Seven hot dogs is nothing to sneeze at, mind you, but whether or not they "count" probably depends on how sentimental you are. You more than qualify as "deflowered" by sheer bulk alone, but there is *something to be said for living flesh and*

human contact. On the other hand, based on Professor X's predilection for tubular foodstuffs and eighteenth birthdays, I'd say that he at least considers you and his other "artists" thoroughly deflowered.

Which brings me back to those royalties. Yes, you and I have even more in common than you might originally have imagined: my parents were so eager to get me out of the house that they falsified my birthday by three days so I could start school a year early. So when the good professor invited me to his temple of masculinity, I chose not to enlighten him about the fact that my real birthday was not for another three days. I also didn't bother to mention that I hadn't been a virgin for years. My pediatrician (also my doctor-daddy's best pal) had taken care of that. He finally took the hint and sent his nosy nurse home early after I showed up for yet another, late afternoon "what-is-happening-to-me-down-there?" appointment.

Anyway, Professor X had searched far into his limited imagination and come up with a cucumber for my birthday present. My pleated skirt, tightly crossed legs, doe-eyes-in-the-front-row act had obviously worked, because he chose a small one for his little virgin. So I batted my big greens at him and asked if he didn't have anything bigger? (Like you, "Kimberly," I love a challenge.) Well, give the man credit, he comes prepared: out of the fridge comes the biggest, longest cucumber I've ever seen. State Fair Blue Ribbon material. In my best little girl's voice I asked for a peeler and carved out a long row of horizontal ridges for my pleasure while he fiddled with his camera and "set" (a leather beanbag chair).

I got into position and worked the zeppelin in and out while he snapped away: very boring. Then I got the idea for the flipbook (admittedly, not all that new or imaginative, but

better than the shit he was shooting). I convinced him it was his idea so he wouldn't notice I was art-directing: bucking my hips at the right moment, "snatching" the cucumber back in on the rebound, etc. Essentially, making that enormous thing "fuck" me.

The flipbook was really hot, needless to say, and it sold well enough that I could quit my stupid student job. How did I manage to share in the profits, you ask? One look at the birth certificate I was far-sighted enough to bring along and we were signing on the dotted line. He's unoriginal but not unintelligent. (Case in point: he covered your face so all the money stays "Chez X.")

On the bright side, he was courteous enough to use the eighth doggie to get you off, something that didn't occur to him during our *session. (Luckily for me, "Doctor X" had shown me* exactly *where to find my G-spot, so I was perfectly content taking care of myself.) Still, it was rather thoughtless. . . .*

So keep thanking your "lucky stars," be grateful that you had such a bang-up good time and make sure you get a copy of that video, because it'll probably never happen again!
Love,
Gina (my real name?)

Note from Gina

Dear Readers:

As many of you will already know I've been appointed Dean of Sculpture at the Hochschule für angewandete Gestaltung und Forschungstechnik in Neussloch, and I'm thrilled! The education environment has always been a particular fave of mine, with its scads of youthful minds and bodies where I can share my experiences and wisdom with the young people who can benefit from it the most.

I remember my own school days at the Grande École Supérieure in Gstaad, and let me tell you that I wouldn't have missed it for the world! What I learned at that extraordinary establishment – now tragically closed after an unexplained bioterrorist attack on the cusp of the millennium – simply couldn't have been replicated anywhere *else. (Yes, you, François, you filthy old goat!) Not only did I learn about a vast array of technical and conceptual issues, I also learned those all-important life skills that enabled me to spring straight from the École's leaky studios and into a filthy garret of my own! Thanks must go to my teachers: Heinrich, who bent me over his frolicking orange I-beams every Friday lunchtime and impressed on me the absolute necessity of solid construction and well-crafted surfaces; Xantippe, whose rigorous three-year Valkyrie-only colloquium* Random Knobs: Video and Technocratic Refusal *allowed me to catch up on much-needed sleep in the dark; and Ashley, whose arduous all-night, even weekend-long, seminars on critical logorrhea and dyspraxic theory taught me enough German to buy a train ticket at the Hauptbahnhof on my own.*

But that's enough about me: let's hear from today's college kids and their mind-boggling probs!

DEAR
GINA: I'm having a great time at art school and am following the extramural program strictly, but there's a problem: I have no interest in making art, I just can't be bothered. The other kids are always hanging around in the studios doing their stuff, you know the kind of thing – video, welding, internet crapola. I really like art school and don't mind going round to galleries and museums and stuff; even going to lectures and reading books and things is doable. I really think being an artist is an OK life-choice for me, but I'm stuck on the art thing. Do I have to give up being an artist? Please don't say yes as it's really helping me to get laid a lot!
Slothboy

Dear Slothboy:

When I read your letter my initial reaction was disgust at the waste of opportunities and resources on lazy bums such as yourself, rapidly followed by a tsunami of ennui at the sheer familiarity of your "plight." But then I looked at the photo you'd sent and completely changed my mind. (Remember, readers, the cast-iron Ashcraft Guarantee is as good today as it's always been: a nude photo ensures a reply!) Close examination of your pic and your evidently considerable personality sent my already rampaging hormones into overdrive. After due deliberation and precautionary lamination of the delightful image, I decided that rather than strongly encourage you to start waiting tables right now, Auntie Gina had better get in touch with her inner, caring career advisor. It's never easy in cases involving idle, spoiled brats, but frequent

recourse to your enticing snap and the tiki bar in the corner of my studio showed me the way forward, so here goes!

First, let me say this: hold onto the dream, you are not alone! We're creative people: rearrange, reinterpret the facts! Know what I learned from Minimalism? Square pegs can *fit* into round holes!

Many perfectly lazy young lads have found themselves in art schools for no discernible reason. It's like waking up in the morning after an evening of wanton beveraging and wondering where the hell you are. Your error lies in fearing you're in the wrong place: you're not, you're in the right *place!*

Students and artists throughout the ages (I'm thinking of the past forty years or so) have been faced with your dilemma, and let me tell you, kiddo, they've never thrown in the towel and signed up for a CPA course. No, they've always sat down with a bottle of Château Thunderbird to get those creative juices flowing and found a way around it. Now, I can't tell you what the answer to your specific problem is (that would be cheating! Auntie Gina can only help you to help yourself! She can't go around just dishing out the answers – unless you chuck bundles of non-consecutively numbered 500 Euro bills at her), but this old bird knows a few tales from days of yore, which might give you some pointers.

The earliest recorded instance of artists with stay-at-home-itis occurred in the sixties. The exact nature of their terminal lassitude manifested itself in a physical form: they didn't mind thinking about their art and planning it, they just couldn't be bothered to get off their fat asses and make it themselves. Probably the most seriously affected man (and believe me Slothboy, ninety-nine percent of cases are male) was Ron Slug. His case was so severe that the guy couldn't pick up a screwdriver without breaking out in a rash; his proctologist

advised him to go with the flow. So, just like those neurotic women with allergies to everything who live in the desert (I mean the housewifey sort, not the arty Santa-Fe-Desert-Dyke sort), Slug had to relocate to a super-remote place, specifically to a specially constructed, unrelievedly orthogonal aluminum adventure park in the sub-Arctic tundra and keep thinking self-important thoughts. (Parenthetically, I should add that I once visited Slug in his Xanadu where he played Kubla Khan – or maybe Ghenghis Khan, I can't remember which – and even the square toilet seat was constructed from aircraft-grade mill aluminum, which thoroughly chilled the Ashcraft ass. And there were a hundred of them!)

The next epidemic occurred in the 1970s when another androgenetic outbreak manifested itself – more guys who just didn't want to do anything. They resolved their problems, mid-life IRS audits, and booze bills by having assistants. You know, fresh, minimum-wage meat, not dissimilar to yourself, who could do all the work for the Big Guys so they could attend to more important and fun issues like abusing everyone around them. The work wasn't hard to make; even the kids could do it with a few screamed instructions down the phone from the first class lounge at Frankfurt. A quick trawl through some really thinky philosophical treatises, bang away at the typewriter for a couple of minutes, and the show's all done!

The final and most recent outbreak – I'm sorry to say this claimed a few ladies too – happened in the eighties. This time the poor dears just ran plumb out of ideas and couldn't be bothered to do anything at all. Natch they still wanted significant incomes, acclaim, glam openings, etc. Their answer was the most radical: don't make any new art at all, just make other people's over again; clearly the entire responsibility for

the tedious stuff could be abrogated to the assistants, leaving the artists to reach new heights of self-indulgence. And income could be maximized by shoving unsold merch from last season into a posh cherrywood vitrine!

So, Slothboy, you can see there are plenty of opportunities for artists who have art-making issues. Learn from history: shiftless egomaniacs can be successful artists. You don't have to give up your dream: just figure out exactly what it is you don't like about making art and work around it. Nail down those issues! Physical or intellectual laziness? Disaffection with making art, thinking about art, or just generalized free-floating indolence? Don't let art come between smug little you and future artist-hood: whether your blockage is physical, cerebral, or just intestinal, don't let production issues bar your path to happiness!

One tip this over-extended artist can pass along: instead of concealing your laziness with mountains of critical exegesis, try working on your strategy for avoidance as the work itself!

Good luck and happy nada!

Love,

Gina

P.S. If that doesn't work try a weekend break at Dr. Benway's Gender Reassignment Clinic in Casablanca. Believe me, when you're an Innie, not an Outie, you'll have no choice but to get the work done!

DEAR **G**INA: Help! I'm a graduate student at your alma mater, the Grande École Supérieure, and no one likes me or my work at all! Both the students (one in particular!) and faculty deride my work and character as joyless, tedious, and retardataire! And now I've been threatened with expulsion!

Let me tell you a little about my work: I seek to critique, de-objectify, and empower the female spirit while exterminating male hegemonies. The specific media – if you'll allow me to use such antiquated elitist terminology – is support hose and used diapers – the very capitalist products that oppress women's bodies and reproduction – which I place in a blender. I then smear the resultant goo over anything I can get my hands on.

Gina, things have come to a head recently. At my degree show, Pandora Spankworthy, the favorite student, was executing her performance, an appalling, lascivious public display of her genitals. I had climbed up into the lighting gantry to install my fifty-gallon drum of pre-blended goo. I'd intended to present my performance (an anesthetic-free crucifixion followed by inundation in goo, with short-term, on-cross interment for the coup de grâce); unfortunately I knocked over the drum and smothered Pandora in my precious goo. I've been accused of jealously sabotaging a co-student's work and threatened with expulsion!
Mildred T. Ant

Dear Mildred:

Christ on a bike, Millie! Don't ever, ever send a photograph of yourself to me again! Or to anyone else for that matter. Even your mother would have a job keeping her breakfast down. I know I struggled to keep the projectile margaritas off my laptop when I opened the jpeg. There's a reason some women wear tents. Know what I mean?

Millie, yours is an especially tough case, probably the hardest one I've had to deal with this weekend. Your work sucks, you're a jealous, vindictive young woman, and you look like something feral that's been dragged through a hedge backwards. It's a triple-hitter that nearly had me floored, but Auntie Gina has a trick or two tucked in her gusset for such situations. It's going to hurt, Big M, nearly as much as your planned immolation, but it's out with the softly-softly and in with the tough love. Let's fearlessly wade in there, readers, and tackle Millie's three nasties one by one!

First off: your work! Jeez! I thought that sort of resentful, hectoring blather was over millennia ago, although I can tell you've been reading Vapid and Hated: Stella Stickgrüber, *the* catalog raisonné *of the (deservedly) little-known Viennese actionist. Listen, Millie, churning out crap like that I'm surprised that you were ever allowed into the glam and hallowed halls of the École! Unlike Slothboy above who thinks he's in the wrong place, I know, Millie, I know that you are in the wrong time! There was a moment, probably around the time you were born, when self-serving gloomy bitches the world over would gather together in fashion-impaired, muesli-strewn covens and dream up separatist, divisive orthodoxies, which they imagined would enable them to take over the world. Guess what Millie: it didn't happen and it never will! The world has moved on and women artists*

aren't angry old slappers: they're perky geniuses working to get all the power, attention, and outfits that they deserve!

I heard about your unplanned intervention in Pandora's powerful performance, in fact I rented the DVD. First, it wasn't a lascivious display, that was a broderie anglaise catsuit with angora trim until you wrecked it. Even your flat-footed faux-Carrie dénouement couldn't take away from the intensity of Pandora's work. Listen, Mill (I wouldn't get familiar with you, but it rhymes with pill): I am perfectly familiar with Pandora's work – in fact I sat on the jury for the last Tirana Triennial and I can assure you that her presence in the exhibition was entirely my choice. Her smart, snappy, Mother Teresa work, "La Stupenda" was the hit of the show – so what if she was starkers and had a swastika on each tit? – and a big boost for Albanians everywhere, even if their role model had to be a dried-up old bitch in a veil. How else do you think she won the coveted "most promising" Golden Koala Prize? When will you learn that students learn from each other, not from reading dreary catalogs of never-weres?

Time you took a leaf out of La Spankworthy's book, girlie! What I'm telling you is that P.S. might actually turn out to be the best thing that ever happened to you: a powerful, authentic peer model, unlike Frau Stickgrüber (who passed away several years ago during a challenging guano-themed performance). Not only did you wreck Pandora's work, you even trashed your own piece in your insane desire for revenge. "Am I jealous?" Seriously, M, is the Pope German? (Sorry to keep bringing up religion, readers, but I think our gal finds antiquated mindsets easy to grasp.) You smother your goo "on anything I can get my hands on." Sounds to me like the thing you most wanted to get your aroma-challenged paws on was Pandora's shapely bod!

Your appearance issues left me stumped, so I called my colleague and good friend Auntie Brenda, the world-renowned Bev Hills beauty expert. After gradually acclimating herself to your image – she wisely started by looking at it through the wrong end of a telescope – Dr. Brenda suggested prayer and a winning lotto ticket as your long-term option, and a burka in the short term. Thanks, Brend!

Millie, Gina's tuff-luv program ain't easy, but I hope you'll be able to take this advice in the spirit in which it was intended; in fact you might want to read it with the spirit with which it was written (ninety proof Polish). Good luck, Millie!

Love,

Gina

NOTE FROM GINA

Dear Readers:

This month, I've decided to have a little fun with my Ask Gina column. Lately, I've been overwhelmed with the amount of mail I've been getting from a particular group of artists who are often overlooked in this column: Privileged White Male Artists.

Perhaps the reason their response has been so great recently is because my column is now syndicated and being carried not only by your favorite art magazine, but also in the arts section of your hippest local weekly newspapers. As my column has gained relevance and attention in the art world, the PWMAs naturally want to be part of the action, if not dominate it totally. I find it a terribly unfortunate reality that in our society asking for help is seen as weak or emasculating. So perhaps these groundbreakers are doing us a service. Whatever the case, one thing is for sure: as soon as problem-solving the candid, articulate, and wise advice of one sage individual becomes popular, the undeserving want to play too.

So without further ado, let's hear the poor darling's troubles and see if they get what they need – if not what they deserve.

DEAR GINA: I've never written to an advice columnist before because I've always thought it was a bit ridiculous to ask a total stranger for help. I feel very unsure about doing this, but maybe you can offer something interesting.

I've been in the art world for about thirty-five years and have all the success, fame, and wealth I could ever have dreamed of achieving. The problem is that I've also been *doing* the same thing for about thirty years now and I'm bored stiff with it! Sure, there have been some minor deviations along the road – I've changed the dimensions and form of some of my projects, done them inside and outside, in institutions and galleries, and once I even used my material in its liquid form. But, basically I feel like a one-trick pony, and worse still, I'm in a total rut that's becoming obvious to my collectors and critics (if not my peers).

The main problem is that I've never really felt that my work truly represents who I am on the inside. A really, really, long time ago I had one great show, and everyone talked about it and wrote about it for months. The next thing you know I've been pigeonholed, and it's the only kind of work I can create. To make matters worse, the attention was/is so great that I just stopped taking any risks and decided to enjoy the ride. I'm afraid that if I try to break out of my signature style now, people will think I've lost my touch, gone senile, or just plain run out of good ideas and am desperately trying to reclaim the spotlight for myself by attempting something radical.

METAL MAN

Gina, the thing I would truly most like to do is performance art. Specifically, I'd like to experiment with Kabuki theater. I've always thought that I had a flair for dance and a lot of grace, but as a well-respected sculptor with a history of success, I'm terrified that changing my style now will result in ridicule, reduced income, and worst of all – bad reviews!

Frightened and frustrated,

Metal Man

Dear Metal Man:

I must tell you how brave it is for you to write to me. Obviously a man of your stature could afford a good therapist (unless a colossal ego prevents you from seeking one, but that's another column).

I think Kabuki theater is dead. But maybe you could bite that acting bug back by starring in a dramatic, theatrical art film? Certainly someone with your power, influence, and reputation could manage to schmooze his way into a grand production by some hot, young, up-and-coming type, who probably idolizes you anyway. I would suggest that the more abstract and obscure the film, the better the chances of you satiating your desires and not falling flat on your face. And who knows what will come out of it? Maybe you'll revive your interest in your work and restart the flagging interest of others. If the acting gig doesn't pan out, just remember this old sculptural adage as you return to your studio:

If it doesn't work, make it bigger.
If it still doesn't work, paint it red.
If it still doesn't work, make a hundred of 'em!
Good luck, Metal Man!

DEAR GINA:

I'm twenty-two years old and a student at the School of the Visual Arts. I've always wanted to be a great artist since I saw that Basquiat movie when I was seventeen. I was totally trippin' and it changed my life. I could hear the NY art world calling my name. My girlfriend totally doesn't get how important it is to me and how cool it is to be an artist, but she's a dumb bitch anyway. And my parents completely don't understand. My dad wants me to go into banking like him and my lame-ass brother Benjamin. I told him: "No way, dude! I've got more important things to do!"

See, Gina girl, I take these really intense photographs and I just *know* they're off the hook, yo. I usually shoot my friends at parties and openings and shit, like in their regular lives, just hanging out and being cool. Sometimes they're really radical. Like one night when we were all on E, this kid Cameron starting jacking off and I like totally started snapping pics of him. It was so hardcore . . . he was making all these whack faces and sweatin' like mad. And I was like, "Cam! Cam! Look over here!" Another time this chick Jen starts yakking her guts up in this other chick's hair after she did some smack. Then they were making out in it and it was totally disgusting because you could see what she ate and everything! Vegetarians always have chunks of undigested tofu in their puke. And of course I'm always catching people on the toilet cuz that shit is just classic high art. All the greats did that one. Actually, in my color crit class,

I'm kinda known for keepin' it real because of the potty shots.

I got a total kick-ass camera for my birthday last year. It's called a Hasselblad and it rocks! My dad was the biggest dick about it though. He was all, "Son, this is an important instrument for your trade, I hope you'll use it well." Whatevah. They sooo don't get me. If I didn't have to go to Connecticut to score some drugs for my girlie, I wouldn't have gone home at all, yo!

Anyway, Gina, back to my problem: I wanna be rich and famous, like *right* after college. And I wanna be on the cover of *Artforum* by the time I'm like twenty-five *and I don't give a* fuck *what I gotta do to get there, yo!*

In the future, I see myself hanging out at Lot 61, chillin' with Moby and my boyz from Mary Boone, surrounded by all these hot, young actresses and fashionistas. Fuckin' the gallerinas during the week and the top-notch pussy on the weekends. Livin' Large!

But my advisor at school is like, "Brandon, there are no guarantees in the art world. You should look at grad schools and consider teaching as an option."

Asshole! He's just bitter cuz he didn't make it. Those who can't do, teach, right, Gina girl? Anyway, you *have* to give me some advice. Like I said: *I will do anything to get my work out there.*

Peace out,

≈*Snapshotz*≈ (keepin' it real in the 718)!

*Dear ≈ *Snapshotz*≈:*

 I think I know the perfect place for you: The Gay Mafia!

I know you said you like girls and stuff, but let's not sweat the details! Your girlfriend's a dumb bitch anyway, right? The homophotos of your pal Cam would be a huge hit! And aren't you willing to get your knees just a little bit dirty for all that fame and fortune? Plus, just imagine how pissed off your dad will be when he finds out you're sucking cock in Chelsea!

I will be mailing you a top secret list of all the galleries in Chelsea that can help you make your way, and believe me, there are plenty! *Also, I'll be sending a list of bars to hang out in, parties to attend, and* of course *the Top Ten Queer Artists to know and blow! You will surely have fame and fortune by the time you graduate. Or at least a few "really hot group shows with lots of promise!"*

As for the Artforum *cover . . . well, the Gay Mafia thing will help, but honestly Brandon dear, I don't think you'll need it. There seems to be an insatiable desire, response, and (hurrah!) market for the kind of sensationalist horseshit that you and your type seem to be so adept at churning out. And the critics just lick it up . . . especially if you've licked them up first!*

*Good luck, ≈*Snapshotz*≈!*

Gina

Dear Gina: It is with great trepidation and seriousness that I write to you.

I am in the fortunate position of being a graduate student at the prestigious and internationally respected Yale University. However, I have a problem that even my professors and analyst can't seem to solve. I know it's highly unusual for you to receive a letter such as this from the likes of me and mine, but I have decided that a common approach may be helpful in remedying my conundrum. Also, I must confess I do adore the picayune, provincial tone in which you respond to your troubled readers, so if nothing else perhaps your advice will afford me some amusement.

I seem to be paralyzed, unable to approach my thesis with the rigor and aptitude with which I have approached my previous works. And I believe the origin of this impasse may be a conversation in which I was engaged one ill-fated night at the pub.

Parker and I were discussing semiotics (*comme toujours!*) and he made the most disturbing remark. He said, "Jameson, language is a relatively autonomous system, and the literary text, instead of being the transmitter of an ideology, or the sign of a political commitment, or again, more generally, the expression of social values, or finally a vehicle for communication, is opaque and not natural." He knew that would really get my goat! I hate it when he paraphrases Barthes! I reminded him that, per John Lechte, for Barthes, what defines the bourgeois era, culturally speaking, is its denial of the opacity of language and the installation of

an ideology centered on the notion that true art is verisimilitude.

The reason this typical discussion presently weighs so heavily on my shoulders is because I'm writing my thesis about a series of videos that I've recently completed on the bourgeois expectations of codified language. In my thesis I refer to the installation as "my piece." As soon as I read the words back from my plasma-screened maiden, I knew there was something wrong. The language itself is troubling me greatly. While I do mean to tip my hat to Barthes' ideology of the bourgeois era (as I do in my videos), I also feel compelled to make my work more palatable for a wider audience. When I wrote my "piece," my whole world came crumbling down and I haven't been able to work in weeks. The word "piece" refers to many issues at the core of my semiotic dilemma. Permit me to illustrate with a few examples:

"I'm horny," Alfonso realized, "I'm gonna go out and get me a *piece*."

Or:

"That nigga done pissed me off," Shaniqua remarked. "When I find my *piece* I gonna pop a cap in his head."

Or:

"From the exhibition at the Guggenheim," Jameson offered, "there was a great deal of press about my *piece*."

Gina, are you still following me? I feel that you must be able to understand my problem, but in case you cannot follow the intricacies of my argument, allow me to explicate further.

If I am attempting to comment on a bourgeois society, and such a society wants signs that do not look like signs,[1] then how am I meant to examine collective representations of a language rather than the reality to which they refer, as sociology does? I do not believe that my language can function clearly in that manner *pace* the untenability of my thesis, much less that of an entire society.

To add to my troubles, I was reminded of my internship at MoMA (NYC, not QNS). My mother had encouraged me to stay with my Aunt Hildie in the UES (seventies, pre-war, classic six). But I insisted I needed the artistic experience of suffering and roughing it if I was to make valid art. So, I chose a modest flat in the gang-infested LES. By the end of my horrifying three weeks there, I had not only memorized the telephone numbers of several car services, but I realized to my utter astonishment and dismay that these LES types don't care anything for art – much less one that acknowledges a linguistic structure obtained from its own self-reflexive criticality. They just didn't care that I was trying to incorporate their language codes into my life's work! Why should I care about inclusivity, even from a theoretical position?

Oh Gina, I'm really in a fix! Can you offer some of your homespun wisdom to help me resolve my issues?

With sincerest gratitude,

Roland Reader

1. Roland Barthes, *Introduction to the Structural Analysis of Narratives*, 1964.

Dear Roland Reader:

I have no idea what you are talking about, and neither do you! But you sure seem to be getting your money's worth there in New Haven. My, what an impressive vocabulary you have!

Normally, letters such as yours move from my desk to the Shred-O-Matic at lightning speed, but this column's a theme and I'm on a generosity roll, so here's my advice.

This is very, very important and crucial to reclaiming your sanity, so pay close attention. You must refrain from reading anything except R.D. Laing and Page Six for the next three weeks. During that time you must go to Yale's ceramics department (yes, they have one) and make twenty-seven ashtrays. It is extremely important that the kneading, molding, glazing, and firing of the clay be timed to specific and precise increments: you must finish your ashtray quota in exactly three weeks. The schedule must be followed without exception or deviation; failure to comply will oblige you to begin the entire *process anew. At the completion of your task you must distribute the ashtrays equally between East 6th and 76th Streets in Manhattan.*

At the end of this process you shall have your answer. Bonne chance, *Roland Reader!*

So there you have it, dear readers. Aunt Gina has shown fairness and tenderness to one of the groups that needs it the least. I hope you all will see that artists from every walk of life suffer the pains of growth, success, and failure in the art mecca that is New York City. And while stereotypes do exist, each and every one of your brilliant creations are unique. Keep struggling, Artists!
Aunt Gina

DEAR
GINA: It's a rainy Friday night here in Gotham – AKA Manhattan – and I'm alone, as usual. At this moment I'm contemplating the point of being a fine artist. I feel washed out at the over-ripe age of twenty-three and directionless in my personal life. I also feel lost and insecure about my artwork and my so-called "career." Along with this mid-career crisis, I have major spiritual questions about the validity of the art world I live in. Sorry, Gina, I tend to vomit my problems onto people, and so I never get a straight answer, and it doesn't help that I never stop talking.

My question is this: what is the point is of being an artist? And does it matter anymore in this recycled world of art commodities and art stars? I mean, nobody gives a fuck what anyone does, art or no art. I think I used to care, or at least I felt that God cared about my watercolors. Gina, you and your work are an inspiration to me – rare exceptions – and this is why I'm writing to you for advice. Please help me, my soul's on fire, I don't know what to do.

I'm very sorry for being so negative. Right now, I'm in the grips of nihilism's iron hands. Nobody wants to show my work, unless it's my infamous watercolors. All I hear when I say sculpture is, "Sorry, we're saturated!" Most times, though, I find a ray of hope because even the most nihilistic person has to believe in one thing, and that is nihilism. All is not lost. I know you and your work are real, and that gives me hope. Once I had the opportunity to hear you lecture on your work, so I kind of feel like we

know each other. Please believe me, I'm not as pathetic and whining as I come across in this letter.

Gina, don't get me wrong, I'm not some naïve Columbia graduate vying for an atta-boy from his or her professor. I never went that route. I had it easy when it came to showing and making money, which seems to be the art world's ultimate goal. What I want to know is how to find my way back onto the path of righteousness. When I look at other artists whom I believe are satisfied and successful like you – most of them don't make fine art. If I were a spiritual leader I'd be the Dalai Lama. If I were a musician, I'd be Sting or even Prince, or maybe Robert Redford if I were an actor. They're mainstream but politically empathetic. These people are heroes in their field and seem to be doing something that has fulfilled more than just their bank account.

I'm just wishing I could feel "real" and spontaneous again. I don't mean to be so negative and repetitive. Most people describe me as a young and charming artist. I just need some solid answers to help me sort out this "art" crisis. I'm a thinker and a dreamer who fell into this roller coaster artist's life at a very young age. I guess I should tell you a little bit about myself and my career so you can make a proper analysis of the situation.

As a painter of Christ and his teachings, I had achieved international recognition by the age of fifteen for my watercolors of stuffed animals depicting the teachings of the Bible. If you think Petite Picasso or the Painting Elephant are big, well, you've got another thing coming. I mean, don't tell me you

haven't heard of Matthew, matthew (my mother and former art manager came up with my *nom de peintre*). I paint from my visions of Jesus, if you know what I mean. I've been on *Oprah, Good Morning America,* and *Primetime.* My work sells all over the world to decorate the houses of the preposterously rich and ardently religious. In addition to my swelling bank account, I've received critical acclaim for my deconstructionalist attitude towards painting. My work has been in two Documentas, three Biennales, and scads of Kunsthallen.

Lately it's been getting even more masochistic and internal than you can imagine, my work that is. I used to wake from my inspirational reveries – visions, really – of our Lord and get straight down to painting my stuffed animals. But now my visions and my passion have left me, and art seems pointless, and God hates me. Right now all I do is look around at everybody else, and see that they are all doing better than me. Sometimes, when I feel so alone, I sit in my SoHo loft and dream about the respect and power that a truly successful international artist can achieve.

It's not the money. I've always been rich and, I mean, anyone can have money. It's not the fame, which comes and goes. After all, I should know, I was a child prodigy. Thanks to my mother, I managed to stretch out being twelve years old until I was sixteen, when sexual content started to appear in the stuffed animal watercolors of Christ. I still love my mother, but she was really tough on me. She thought I was a direct channel for Christ and his teachings, so my watercolors always came first, polio or no polio.

"You have to want it, you have to put it out in the universe and believe it will happen," that's what my mother used to tell me. If you don't get it out there into the universe and believe that it's going to happen, it won't. I really did believe, Gina, but still God's visions left me, and so did my passion. All I do is sit around and pray and complain. I also miss my mother's approval of my artwork. I'm sorry to whine so much, but as you know most artists learn it as a matter of discipline. I have a top ten list of things to change about myself and reducing whining is right at the top.

I guess you're wondering why I lost faith in art. As I said, I got involved at an early age (the art world loves youth) making watercolors of my stuffed animals. (And in case you were wondering, I had never seen any of Mike Kelley's work.) At the tender age of eight, I became a conceptual watercolorist deconstructing God for the art world and utilizing my medium to talk about longing and isolation for the conservative and religious at heart.

At that time success for me was an unlimited amount of candy and toys, along with the approval of my mother/art manager. Her business sense and CalArts education (she was part of the women's movement in LA during the 1970s) helped my career quickly achieve international success. The increasing profits and demand for watercolors never stopped. I was the Drew Barrymore of the art world.

Deep down inside, in my heart of hearts, I wanted to make sculptural objects, but it had to stay a guilty three-dimensional secret because of my mother.

Technically, I was already making sculpture, with the arrangements of stuffed animals, but then painting them. Sculpture seemed to me a much more effective way, conceptually speaking, to convey my ideas to my audience. It was the combination of hitting puberty and seeing Donald Judd's work that caused an internal explosion, a conceptual meltdown, and that forced me to abandon my watercolors – despite their beauty – and pursue a new body of work, without my mother's knowledge. Gradually, I began to despise the commercial side of my work and even though I continued to paint my visions, things had started to stray.

That's when my mother found my first minimal fur cube and freaked out, telling me it was the work of Satan and that Christ never talked about cubes in his teaching, especially fun-fur ones. After a long drawn-out lecture on the importance of my watercolors, I realized that I had to get out from under her parental umbrella once and for all – and make the sculptures I believed in.

My new objectivity came with the price of losing my visions from God and my mother. Also, it became apparent that there would be no chance of showing these works because everyone still saw me as Matthew, matthew, the child prodigy watercolor painter. In the last two years I've become completely isolated, and without any audience I feel a sense of emptiness, along with an overwhelming amount of guilt that has taken over my selfish desires to be a Minimalist. Matthew, matthew has been crucified by art and needs a reason to continue. Does making art

matter if nobody wants my true work?

Sincerely,

Matthew, matthew

Dear Matthew, matthew:

I appreciate your letter for its brutal honesty and the interest it has for other readers who are stuck in similar situations. You are not alone. I've received numerous letters from artists who have been exploited and forced to produce commodity-driven artwork, when all they wanted to do was teach scuba diving or cook in a respectable restaurant. I think that writing this gaping wound of a letter and turning to my column for advice is a giant step in the right direction. I am familiar with your work and the predicament that it has placed you in. (I never saw any relationship to Mike Kelley, more Kim Dingle if you ask me.) Anyway, I hope to offer you some advice and direction to help you exit the bell jar you've made for yourself.

Recently, I was entertaining some houseguests from Berlin, two trustifarian kids, who were doing well as artists in the contemporary art scene in Berlin. They were making works about the fall of the Berlin Wall and the openness of the new system they were forced to participate in. The interesting part of the artwork was they were born in West Berlin and grew up in a privileged environment without ever doing a day's labor, or having to struggle to support themselves as artists. Yet, the work was specifically about oppression by a governmental system that only a leftish democratic nation could create. As a critique, it didn't really work because the environment in which they showed was so accepting of their Prada suits made out of chain-mail that it failed to be much more than a readily-digested jab at the liberal norm. They

wore the ponderous suits to the openings of their shows to ex-press the weight and oppression that the new democracy gen-erated. In the end, everybody thought they were just absolutely fabulous.

These unnamed German artists had always dreamed of making art in the East under the old communist regime, where they could be truly persecuted for their anarchist ideals. They needed a place where they could work against the grain, instead of always being accepted for who they were and what they stood for. They wanted to be misunderstood and tortured for their artwork. They wanted to make "heavy" works of art, not just outfits.

Eventually, they felt oppressed by the freedom and the progressive environment in which they grew up. In this per-fect German world, they were able to study for free and live any type of lifestyle that their hearts desired, no burdens. In their formative years, both artists found they had no limits to push against, no resistances in their audience, and so they became lazy, privileged people with nothing to rebel against. At a certain moment, they stopped making work as a team and decided to do nothing as a form of art (probably one of the most important works of art dealing with the emptiness of modern culture was Roberta Smith's trenchant critique of the duo). Anyway, success and acceptance were slowly killing the two artists.

I was introduced to the apathetic artist team through one of their former professors who'd convinced me to invite them for a stay in New York. They had never left Berlin and she was convinced that they were in a pathetic space because of the delimiting microcosm in which they lived.

This is my first point in response to your letter, Matthew, matthew: you were living in a microcosm that was

*governed by your mother, and now you have finally broken
out and seen the world for what it truly is: a lonely place, a
place where you find your independence, think for yourself,
and make decisions for which you take full responsibility.
You have to make and wear your own suit of armor in this
world, a strong carapace that will protect you, not sluggard-
ly gladrags to retard you: it's your social apparel. I can see
you're finally starting to live your life as an artist: you've
just started with your protective underwear. This newly
found escape from your mother's capitalist regime is a begin-
ning* and not an end, *a route to a brave new world of in-
dependence. Your entire adolescence was governed by your
dictatorial mother, who sounds like she used you to project
her own desires as a failed artist.*

*The reverse was true in my German experiment; they
had nothing to break away from, nothing to use as a foil for
their work. Even though they opposed the system, its liberal
vacuum sucked everything into a big black hole and turned
it into positive manure, fodder to mulch the hierarchy. It be-
came clear to the German couple during their stay in New
York, just how useless the privileged can be.*

*The climax of the German duo's stay in New York came
when they decided out of their so-called generosity to take my
clothes to a laundromat. They had discovered that I didn't
own a washing machine. Being the privileged, unoppressed
individuals that they were, they had never actually washed
their own clothes. Only after an extended period of time did
they manage to get the public machine started, and attempt
to wash my clothes. They knew bleach formed an important
part of the washing process, but weren't clear about its exact
purpose. In the end, they managed to bleach all of my brand
new clothes that I'd just bought from APC. The bleach was*

a huge conceptual breakthrough; it became a turning point for their development as artists. An act of chance had inspired the Germans to make artworks again. Something outside their known system had occurred and opened their eyes.

The second point in response to your letter is that we all live in a state of what I shall dub "the unknown" from day to day. The unknown is the thing around the corner that we don't know. We all have to realize that we live in our own bubbles. Until you realize that the unknown is always just waiting to be discovered, you will be in a self-constructed prison, to which only you have the key. The German couple found that no matter how much they thought they knew about everything in their microcosm, it was still subject to their location. In other words, only you can find the right environment to express your new desires, to make sculptures, and just because they aren't an instant success like your prior watercolors, doesn't mean that they are pointless. To be honest, we are our own worst enemies. To answer your question as to what is the point of being an artist, or whether anything matters, seems utterly pointless. If you don't find art satisfying and self-fulfilling and think it's nothing more than a commodity, then stop. Do something else. There are already too many artists to begin with.

Matthew, matthew, don't take this tough love the wrong way; I appreciate your openness and willingness to seek help for the answers to your questions, but it seems you have the answers right in front of you. You're caught in a self-inflicted tunnel-vision trap and you need something unknown to happen to you to shake your foundation. Maybe it's time to travel, even if it's just in your mind.

My third and final point is for you and all my readers who have been questioning the validity of the artist: stop

wasting your time and live your life! Once the Germans were willing to act as things came their way, they failed to need something to rebel against. Their next solo show was stretched canvas with landscapes of bleach, always looking forward, out into the horizon of life. They found the inner strength to embrace the unknown, and to find the context in which to address it.

Life and art is an ongoing process. You can't just pick and choose the way it goes. What you can do is believe in your dreams and make the best work you can. Do you love your dreams, Matthew, matthew? What are your goals in life? You need to pull out the road map and see in what direction you're going, with recognition or not.

In the end this idea about art is somewhat juvenile and privileged; just look around and realize the richness of what we all have merely being alive – the air we breathe, the smiles we get from our friends. I know that everybody has their little life storms at times, but the unknown is always around the corner to help keep us on our toes. I think we should all learn from my German guests. Go out on a limb and try something new, jump into the unknown! Keep sending me those letters!

XOXO Yours,

Gina

CLUB GINA

Dear Club Gina Fans,

Here is a selection of images for the terminally visually ori-
ented, sent to me by my adoring – and adored – readers.
Love,
Gina

En dépit de so
Angélique n'es
loin de là. En f
sensuelles ado
seins. Elle se f
touche en fant
ont le mandrin
ses rondins. Qu
finalement son
littéralement d
foutrement se b

(76)

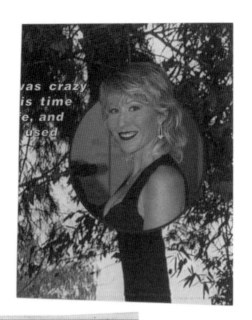

...vas crazy
...is time
...e, and
...used

UNCENSORED

06. COWGIRL DESIRES

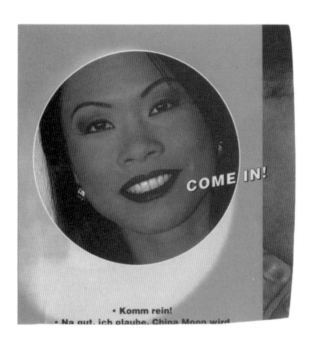

• Komm rein!
• Na gut, ich glaube, China Moon wird

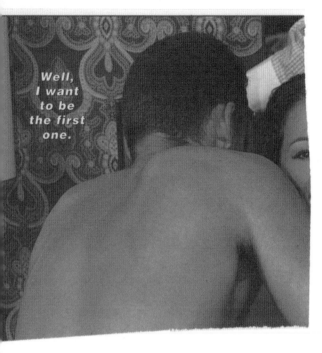

Well,
I want
to be
the first
one.

Jeder Erfolg hat seine Geschichte.

Note from Gina

Dear Readers,

I just saw Jean-Luc Godard's Two or Three Things I Know About Her *for the fifth time. If you haven't seen it I highly recommend it, at least once. The film, which was based on an article originally published in a French weekly, is a biting document of a disease called capitalism. Godard's damning portrayal of suburban consumerist Paris is centered on the lives of a few housewives who resort to prostitution in order to fulfill needs created by a greedy society. It is in this modernist setting that Godard reveals a world where people and things do not live in harmony. It is a world where people become objects and certain objects become more real than people. (Are my Siskel and Ebert tendencies beginning to show?) I always secretly wanted to be a film critic. Pedantic is the way to be! Anyway, back to Godard: take the carefully scandalous scene where the American war correspondent uses Juliette and her friend as objects, photographing them as they parade naked around the room, further dehumanizing them by insisting that they cover their heads with bags. This is a grand example of a hard-hitting Godard implying that everybody – each and every one of us – is forced to prostitute himself in a modern society. And yet,* Two or Three Things I Know About Her *is reflective rather than polemical.*

Oh, dear Readers, I sit here now, with my cup of black coffee, sugar bubbles slowly rising, and I reflect (as Godard does on society), on the very existential questions that you readers pose to me daily. I reflect on language and the impossibility of conveying through words (which define and limit) the complexity of the world. I feel with all my heart the calm pessimism that the film evokes at its final moment, where death reveals itself as the final absurdity of life.

Note from Gina

In the following selections of both published and unpublished letters, I wish to expose my humanness to you all. Aunt Gina is not without her faults and problems too! She disappears, never answers, and is even robotic! She is lazy and depressed, incapable of finding angles and words when she finds society so terribly disappointing! She embodies the word "dysfunction"!

DEAR **G**INA: My art dealer dresses like a slob. Normally this wouldn't bother me, but when he wore a stained American Eagle T-shirt to my opening, it was really too much. I'm aware that the art world has more relaxed standards than the rest of the business world, but one should show a little decorum. For example, a dealer should distinguish the opening of one of their more . . . august artists from, let's say, watching a *Baywatch* marathon with a case of chilled Bud and a family-sized tub of Cheez Whiz. Is this bourgeois? Or am I right to dictate the level of acceptable grunge from the man who represents my livelihood? T'ed off in Texas

Dear T'ed:
Better than a tuxedo T-shirt. . . .
Gina

D EAR
G INA: I admit that I am at loss for what to do about my lonely snail. A good friend and I traded artworks a year ago. The trade was at her suggestion and I was willing because of my fondness for her and not for her paintings. I am holding a dinner party in a month and this same friend is on the guest list. Here is the problem: she'll probably be disappointed to see her pastel snail hung above the bidet. I do not wish to hurt her feelings; on the other hand, I don't want to give my other friends the impression that I am utterly tasteless. There could be consequences. Some of the invitees are collectors and one friend's husband works for a reputable interior design magazine that is considering my home for a spread. If my house is chosen, this article could draw considerable attention to my newest body of work. And where else, logically, could one hang an impasto cream and pale green snail with pink tints and lemon highlights but above a bidet?

Calculating in Compton

Dear Calculating:
something about being sluggish
Gina

Dᴇᴀʀ
Gɪɴᴀ: I've been an artist for nine years now. I start-
ed as an undergrad in my year abroad. Al-
though I was a philosophy major, I visited numerous
galleries and museums, exposing myself to the finest
artists in the world. My thirst for contemporary art be-
came something of a mania. The more I whet my pal-
let, the more insatiable my thirst became. I soon
realized that I could, nay! I must become an artist. But
what kind of artist?

From my research, I was well aware that graduate
schools in the US were pumping out almost 3,000
MFAs into the unsuspecting world every year since
1990. By the time I'd graduate from art school there
would be 51,000 people in my age group thinking
they're the next Matthew Barney. That's approximate-
ly 7,650,000 pounds of aspiring artist flesh seeping
like raw sewage into our cultural groundwater. How
could I compete?

I studied the artwork of my opposition. The more
I saw, the more I realized that most young artists don't
actually create art, they simply approximate the work
of other artists who have already achieved financial
success. Everywhere I looked, I saw a Nauman meets
Red Grooms or a Burden bangs Brakhage, a Sher-
man-infused Hamilton or a Baldessari buttering up
Botero. I knew that I had to create something com-
pletely different, truly unique, a cipher in the world of
clones.

But what?

I didn't know until I saw a volume at a bookstore

entitled *The Blurring of Life and Art* or some such thing. (I didn't actually read the book for reasons that will soon become obvious.)

Yes! I thought. Perfect! I will live my life as an artist, but completely outside of the realm of artists. Not an "outsider artist," per se, but an artist who is truly outside and who is, herself, art. All of my "life" decisions will be based on their completely antithetical status vis-à-vis the rarified art world. I will make my very existence a clandestine artwork that will fly in the face of all art that has come before it. This work will be 24/7. It will be a magnum opus. Through my very being, my temporal shell, I'll illuminate life itself. Each decision made will consciously emphasize this idea of the commonplace, blurring the edges between art and plain old life. It will be a celebration of the regular Joe, glorifying the quotidian with attention to detail, epic scope, and fervent dedication. The key of the endeavor would be to obscure, confuse, and smear, to the point of being indistinguishable, my "artist life" with the American norm in all its banality.

As soon as the thought occurred to me, I threw down the art book – its very touch made my newly art-infused fingers burn – and headed to the diet section of the bookstore. I was certain that the new, non-artist me would be concerned with firming her unwanted cottage cheese thighs. I bought five books: a diet book, *The Bridges of Madison County*, *The Rules*, *The Complete Idiot's Guide to Reinventing Yourself*, and *The Corrections*. I had some catching up to do on all things un-esoteric. I needed a crash course in popular culture.

I watched television for a month straight. At some point, while flipping between *Judge Judy*, a *Friends* re-run, Fox News Channel, *Sorority Life*, and *Countdown: The Fifty Hottest Celebrity Asses* (by then I had become adept in synthesizing information from four-to-six television shows simultaneously) I realized that, by behaving so extremely, I was still being "an artist." I needed to get on with the project, or my "so-called" life (as they say).

Awash in information gleaned from TV, I now understood that I needed to find a love interest, a career, and "regular" people with whom to share my complaints about all three. I decided on Russell Crowe as a love interest. Not because I thought he was at all sexy (Benicio Del Toro is more my type), but because I knew that most American women believe him to be sexy. I bought a poster of him squinting into the sun, all his movies available on video, and his DVD: *Texas*. At first the thought of him turned my stomach. Through months of hard work, however, I taught myself to love him. I could even orgasm by visualizing his man-boy face while singing along with his song, "Oblique is My Love."

Next, I needed a new wardrobe, one that announced my desire to be seen as completely void of any outstanding features. Of course, that meant the Gap. I bought everything that the sales people said I looked good in, all the while studying their hair (calculating the general mean in shade and length) so I could style mine accordingly.

I got a job at a bank. I started as an Information Specialist, but soon moved my way up to safe deposit

boxes and then CDs and loans. After a couple of years, the bank trained me in their corporate program and I became a manager in charge of tellers. I dressed in beiges and navies, drank caramel macchiatos (which I pronounced wrongly when I ordered) and watched *The Days of Our Lives* during my lunch breaks – I divulged to my co-workers that Sami was trying to use Lucus and rooted for the supposedly unlikely (but in all truth completely predictable) pairing of Bo and Hope. I dated men in business suits who had hobbies and read *Sports Illustrated.* I got a fluffy white cat whose feet I dyed black so that I could call him Mr. Mittens, hung out with work friends at Applebees, and developed a discreet drinking habit. On "casual Fridays" I wore pleated high-waisted jeans with a brown leather belt and white tennis shoes. I listened to pop music and divined the subtle differences of the stars who, hitherto, I had found indistinguishable. I went to church, gained fifteen pounds, saw a therapist and went on Prozac. I joined the unofficial Russell Crowe fan club. I started sleeping with an investment banker with whom I could reach orgasm if he spoke to me in an Australian accent. We married. I quit working when we moved to a small Midwestern town where he got a better job offer.

All this time I'd been doing everything according to my plan and keeping fastidious notes on my complete and utter immersion into this epic project. But one bleak (oblique?) day in early winter, I realized that something was terribly wrong. The notes.

If I was really to fully become this thing – to fully actualize an artist's complete annihilation of self, to

completely lay down my life for the greater good of art, I had to get rid of those notes.

I threw my Dell laptop into the back of my leased Toyota Camry and drove to a suitably remote spot. There, with an Olympic discus thrower's flourish, I tossed my computer into the Mississippi. The notes sank below the ice-patched river into the sludgy depths. My break with the art world was complete. Nobody knows about this grand project or that I harbor, at every moment both waking and sleeping, the greatest artwork unknown to humanity. And no one, no one on this continent suspects that I was ever interested in art in a serious way.

Sometimes my cleverness impresses even me. For example, once my husband asked me if I wanted to go a to a museum to see a much-lauded show. At first I panicked. Does he suspect me? But then I devised a devious plan. I suggested that we instead go to Outback Steak House, and after dinner I give him a BJ in the back of his SUV. Ha! Fate's plot to uncover my secret was foiled! I have a cousin who considers himself to be an artist (completely banal work – Lawler meets Pollock). To throw him off my tracks I always ask him to explain why, exactly, is Warhol an artist, which he does poorly and in the most supercilious manner. Annoying as his Pop soliloquies are, he is effectively put off my scent. Problem solved.

Everything is going so well that at this point, even if someone from Europe ends up in our small but growing town and recognizes the "new me" and says, "Hey, didn't I see you at Beaubourg?" or "You! You were sagely considering an artwork at the Serpentine!"

I can simply fess up to it. (Oh! So brilliant!) Not fess up to the whole project, but to the fact that I once dabbled in art. Just another embarrassing youthful secret like Bush's cocaine or a co-ed's lesbian dabblings. No one would be the wiser.

The transformation is perfect. They are all fooled. Even this baby lurking within my stomach (now it tosses, now it kicks), even this thing will believe that I am its "mother."

But now I wonder how I can deliver this work to the world, especially if exposing the artwork would ruin its epic purity. The only solution is that my secret must, somehow, be revealed before I die.

On Main Street, we have a gallery right next to the dry cleaners. (I've already decided that, two years from now, my character falls madly in love with the owner of the dry cleaners and has an affair that my husband will find out about soon after.) Now, I've noticed the owner of the gallery giving me the eye when I linger by his window pretending to adjust my hose. Perhaps he is on to me.

There is a remote possibility that, contrary to his god-awful taste for pastoral landscapes and *Glamour Shots*-style portraits, he is an uncommonly intelligent man, one who can discern a suffering artist's soul when he sees one. He will become curious about my efficiently prosaic lifestyle (so obviously contrary to what anyone with half a brain could discern as my unique, refined temperament). He will ponder its dreary rhythms and get drawn in further still. He'll hire a private investigator to do a background check on me and his suspicions will be confirmed when he notices

the subtle "break" in the trajectory of my life after I came back from Europe. He'll buy a telephoto lens and spy on me from his '75 Impala. He'll summon the courage as each meticulously thought out detail of my life (in its stunning normalcy) sings its siren aria that he alone can understand.

He knows that he is witnessing something . . . almost unspeakable in its exquisite magnificence. He will feel compelled to share it with the world. He confronts me in the freezer section of the Winn-Dixie. I deny everything. He yells, eyes flashing and fingers digging through my Old Navy sweatshirt to the artist beneath. I'll reach back for support, my hands clutching at a frozen loaf of garlic bread, long, cold, and pungent. His muscular leg thrusts between mine. He'll demand that I tell him the truth. I'll try to deny it, but I will know that I've been beaten at my own game. Bested, but by the best. After a passionate weekend at the Hideaway Hotel, he'll start making phone calls to set up museum retrospectives worldwide of my (literal) body of work. I will be heartbroken that my project has ended, but perhaps a little gratified to be relieved of the burden of dedicating an entire life for art.

But what if he doesn't unravel my delicious subterfuge, to (as they say) discover me. Or what if it's too late? What then?

Blurry in Bloomington

Dear Blurry:
 . . . ?

HUBBARD

*Gina Ashcraft has been missing since the beginning of last month.
As a sign of our continuing support of her invaluable work, we are
publishing extracts from her email. – Eds.*

gina
　　i hope you can help with my dilemma. i'm a young
buck of an artist and i paint delicious and irresistible paint-
ings of mineshafts. my first solo show was a huge success
garnering numerous sales to american and european con-
noisseurs. i received some boffo reviews and am hoping for
the all-important artformen article to come out this summer
(ideally in time for the basel art fair). my problem is that my
dealer is an earnest type who gets off on selling to smart
and nice collectors and jabbering with intellectuals about
the enormous potential of my work and the need to let it
flourish without excessive market pressures. i'm afraid i'm
going to miss out on the huge new york-shaking career that
damian, matthew, and eric have had and i don't know what
to do about it. i've made some suggestions like spreading
rumors about how my paintings are already trading on the
secondary market for several times what they sold for last
year, getting myself arrested, or spending a "clandestine"
weekend with some euroslut artist, but my dealer is having
none of it. gina, you've had a brilliant career and i know you
will give me good and savvy guidance. i can't miss out on
being the next artist whose first name is on the lips of
every sharp tack in the art world.
anxiously,
hubbard
hubbard@makemonjour.com

Hubbard:
　　For a careerist you are pretty slow off the mark.

What was going through your head when you signed up with your gallery? Where one first shows is so crucial – so primary. Either you go right for the hot stuff, or show at an establishment so ridiculously beneath you that no one cares when you move on to the chop shops. Leaving a good sincere gallery will brand you with a scarlet "A" from which you might never recover. Maybe you only think you want your name to be the next art world mantra and can't accept the good fortune that has already come your way. I'm picking up signals from your lower-caseness and am torn between writing you off and booking weekly therapy sessions for you. By the way, what do you look like? Based on recent occurrences, I need to see some photo-documentation of your lifestyle so I can accurately evaluate your "ka-ching" potential.

Gina

gina@l'etranger.com

Gina, l'etranger?

Are sincerity and careerism mutually exclusive? I guess you are telling me to come up with a strategy that is somewhere between crass and ivory tower-ish. I know all about the strings that are pulled to make the dolls dance and – of course – I'm working that angle at all times. My social life is an all-points-up pyramid of cool openings and mutually advantageous studio visits. What's up with you – do you ever hang down on Rivington? I could give you an introductory view of my ways.

Kindled,

Hubbard

hubbard@makemonjour.com

Hubbard:

Was that a studio invite or harassment? I don't have time for juvenilia. I'm getting ready for my opening in Nice next week (Thursday, 5-7). Later.

Gina

gina@l'etranger.com

g:

easyjet to nice (via amsterdam) . . . hmmm . . . only 87,80 euros . . . i'll know who you are. . . .

h

hubbard@makemonjour.com

Dear Gina:

Do you think the road to stardom can be paved with beautiful, successful older chicks like yourself? I'm a pretty isolated type and need some helping hands getting my career off and running. I was thinking about introducing myself to some serious women who already paid their dues and are ready to share with a young, kinda nerdy, hotty like myself.

Jayson

jayson@getjiggy.com

Dear Jayson:

If you have to ask, you really don't know, do you? I don't have time for dimwits. I gotta get my gear over to Angkor Wat by Friday. How are you with donkeys?

Gina

gina@l'etranger.com

Dear Gina:

I've heard you've been very supportive of women artists

and I think it's time we met. I've been exploring the post-rational in architecture for the past four years and I'm seeing my ideas everywhere. I've done the basics – put slides in registries, smiled at desk assistants as I sign in after seeing good shows, hung out at the Kitchen, P.S. 1, and the Knitting Factory . . . no action. I feel my work warrants serious attention but can't come up with the right way to get it seen. If I sent you some jpegs would you open them? Heaven would be a studio visit from the Great Gina, but I'm thinking you must get a million bitches hanging out their tits for same. How can I show you I'm special, and that if you help me achieve the attention I'm certain I deserve, it will be a feather in your cap? Help me, advice chick.

Nadine

nadine@girlfriends.com

Dear Nadine:

It's true I lean over the line to see good girls get the attention they deserve and do my bit to redress the ton of disadvantage they experience out there. But you have to get your work out there for me to see it and build up a little support group before you get the Gina imprimatur. I mean, what will my words be worth with no herstory to back them up? Gina's advice is look to your own resumé first – what about your teachers and fellow students – or did you burn those bridges already? Gina needs a mini-history before she can cut you any serious advice, young lady.

Gina

P.S. Has anybody seen your post-rationals? Maybe you'd better jpeg me after all (by the weekend if possible).

gina@l'etranger.com

Roman

Ciao Gina:

I'm writing to you from Roma and you know the mood here is so beautiful all of the time that my labors are few. I think all day and my beautiful thoughts make me feel like a true artist. People ask what kind of artist I am and I don't know what to say. I'm wondering if you think there can be a new movement of conceptual art – thought art – can we just keep it in our minds? When Lawrence, Ian, and Stanley made their work nobody thought it could ever sell and I'm wondering isn't thought art just the latest challenge for the museums and galleries? With technology advancements happening every moment, perhaps the viewers (and collectors) could come to my work somehow. I love to create in just the mind but at the same time I want my work to be known as I think it very important and too special not to share with the world. Have you ever thought like this and reached any conclusions, or am I the first? Share with me your true thoughts. Gina – would you support my concept?
Roman
roman@giovannisroom.it

dear roman@clef.it
beautiful thoughts seldom to heaven get. . . .
gina@l'etranger.com

systemadministrator (postmaster@clef.it)
gina@l'etranger.com
Your message
roman@clef.it
did not reach the following recipient(s)
roman@clef.it

Dear roman@giovannisroom.it:

When the system administrator bounced back my pithy response, I felt I'd been accorded a second chance. After all, who am I to write off your inspiration so quickly? I too love the idea of thinking as art – for one thing, so much can be written off as studio expenses. Rome is one of my favorite capitals – tell me more about where you do your thinking. One thing I've always loved about travel in Italy is the civility of always getting a mini-bar in one's hotel room and having endless options for perfect espressos at all times. The Italian regard for quality in daily life is endemic and finally it has led to your proposal for beautiful thoughts to be artworks in themselves. On reconsideration, this idea is so big that I think we'd best organize a season-long symposium. I'm thinking gorgeous little castle, with Lear jet services, stimulating cuisine, and fine beverage opportunities. Personally I prefer Prosecco to champagne: it is simply so much more thoughtful. I'm thinking Lawrence, John, and myself could attract the funding you have conceptualized, no doubt. There's nothing like visuals to get a project going, so if you or your personal Alice B. Toklas can send me some, I think we could progress.
Gina
gina@l'etranger.com

Bellissima:

Many warm thoughts to you for your gorgeous response. I welcome the chance to share with you and your valuable colleagues the way to create something new and special. I'm making one of my rare travels to Lisboa at the end of the month and wondered if we could co-ordinate a

meeting. After Roma, Lisboa is my favorite European capital and I know from your profound biography it has special meaning for you as well. Perhaps we could spend a week or so at Cabo Especiel and plan a symposium. For the highest attainment of thought, there should be no time limit, and perhaps we should create sympathetic refuges in several places. I think of Merida, Taipei, and perhaps something tropical – would Tahiti be too moist? I'm sure our meeting will show us the way this important concept should be furthered. I usually travel with my sister, Marisa, as she has always soothed and facilitated me to the beautiful stasis at which I am my most productive. Aside from first class tickets and a beauty budget, what makes travel possible for you?

Ciao,

Roman

roman@giovannisroom.it

Dear Roman:

My yearning for your concept grows with each communication. I itch to telecommunicate these qualities. Perhaps we need to practice a bit before we meet? I'm thinking platforms, platforms, platforms, and I'll be amending my ever-changing travel schedule accordingly.

Gina

gina@l'etranger.com

Dear Gina:

I'm sorry we missed each other in Nice. How could I have known you'd skip the opening? Your installation was brilliant, and I lingered for days hoping you'd return or appear from wherever you were hanging. I hope the museum

people didn't hurt you too bad. It is so stressful to be creative and polite. Finally, I left Villa Garçon and went to the casinos in Monte Carlo. I can be very obsessive and insanely focused when I'm at the game. As I placed my bets, I fantasized you'd saunter in and double down on my wagers. Despite the distraction of this, I managed to bankroll a bunch and would so love to blow it with you. Are there art materials better than money? Gina, please let me know if there is a locale where we can finally meet. I'm thinking of heading to Düsseldorf as I've heard the students at the Kunstakademie are so special, and perhaps time with them would give me the chance to learn how to be the best artist I can. I'm haunted by my shamelessly career-driven inquiries to you. You've opened my eyes to the need to be strict and devout about my art and I so long to experience your wisdom. Please respond before I blow all my resources on worthless time-filling, mind-altering distractions.
Hubbard

P.S. A buddy of mine is taking me to a post-opening dinner at Dimestore Gallery. What do you think about their program? Is it just too much of a revolving-door-wheel-of-fortune to be taken seriously?
hubbard@makemonjour.com

Dear Gina:

I jpegged you as requested but have yet to hear your response. Do you think my post-rationals have merit? I'm on tenterhooks waiting to hear. I feel that some reply from you could cause a general growth in my work, and that is my greatest dream. As I write, I'm traveling with my aging parents. They are determined to show me the architectural wonders of the world. They are terribly dear and all that, but what can I expect to learn from them? Their concept of

wonders runs to Gaudí and Louis XIV, and I know I'd be bet-
ter off going to La Tourette and Vals. If you could let me
know where you are I'm sure I could sidetrack them – per-
haps they'd go for seeing the great cathedral in Köln with a
stop at the Erzbischöfliches Diözesanmuseum, or maybe a
visit to the Jura. Just a clue from you could lead me to the
right place. Please, Gina.
Nadine
nadine@femmefreundlich.de

gina@l'etranger:

remember me? you totally blew me off and asked me
some inane question about donkeys. i tried to think what
you were suggesting to me and I could only discern that
you think i'm an ass. you aren't supposed to belittle the
people who write to you, gina, and i've been getting pretty
steamed up thinking about your callous remarks. i'm not
someone who forgets easily.
jayson
jayson@adishbestservedcold.org

*We recently re-established contact with Gina. During the past six
weeks she has been through every communication hell imaginable,
including having her cell phone locked in a security deposit box, the
key to which was left in a hotel suite in East Timor. We are happy
to report that she is of good health and mind and her regular col-
umn will reappear next month. – Eds.*

DEAR GINA: I am writing to you about a recent problem I have with my G5retrofit implants. A year ago, I opted for the retrofit upgrade (sculptura forte) on the basic G5IBIza model. Since then, I have been experiencing lots of operative inyerface malfunction. Most notably, these agitations occur in rapid hypertonality during my own exhibition galas. I haven't quite located the category, but I think it is the ww/zona 4LottoClover. It's like I am standing there talking to a curator or critic or collector and my access networks are processing every possible appropriate response to their utterances, but all I can ever respond is "groovy." What's more distressing is that the promised amnesiac delete option only kicks in with copious amounts of vodka, which, as we know, costs more than huge amounts of cash these days.

In the past few months, I have been examined by every sculptura rep in the immediate area, but haven't been satisfied with the tweaking capabilities of any sourced ritual. What I am left with is a 5,379,000 trillion-terabyte storage block of inaccessible data which effectively chokes all fundamental inspiration inputs. Several reps have referred to this operative inyerface malfunction as SHMIE – a Severe Hypersensitivity to Manipulated Information Enablers, a hideous grid deformation that stimulates overproduction of regenerated cash potentials. This is deadly for any of the original art impulses. It seems that I am not the only one suffering from SHMIE. Gina, now more then ever we need your radical optimism.

Best regards,
Restylene

P.S. I love your work. As a fellow fosilsculptures-sa, I marvel in your originality and beautiful invention.

Dear Restylene:

They say the information age has made a world of information and commentary accessible to everyone. I say one person's information can be another's misinformation. Even the most astute locators recognize that information alone, delivered indiscriminately, is not enough. That's why I assume you chose the value-added opportunity to upgrade with sculptura forte. In theory, the retrofit should combine the insights of concept with an understanding of your individual optional goals. It should put that information into context for you and direct your active conscience accordingly, giving you a well-rounded sense and ability to identify conduits and their powerful networks as well as eliminate your need for middle managers. I applaud your decision to get the implants, Restylene, and would like to help you get the best performance from them. Let's check the five fundamental settings together and see if your mechanism is co-ordinating correctly. Get your tool set ready and find a mirror!

Setting 1$: Is the MFA Complete Verification intact and sporting a gold waxy seal stamp?

Setting 2$$: Warholasmear 11 Quickstep is deactivated and permanently divorced from the style section 21.

Setting 3$$$: Museum bLockbuster potential is cancelled.

Setting 4 $$$$: Cristie'So'beBAsel has been properly buried in the no-added-value IRS10 section.

Restylene

Setting 5$$$$$: le(a)d logo is illuminated and blinking. It reads: Money is a symptom of poverty (© Krugerholz, ca. 1975).

It is really true, Restylene: money is a symptom of poverty. I am proof! Gina Ashcraft, at the peak of her profession producing thousands of workable visual ideas every day and giving them away freely, gratis, to the very people who will make fortunes with them. In return, Gina has virtual immunity from the tyranny of cash. Gina never has to pay for anything! I am truly rich! You too can be rich, Restylene, you and your colleagues in art. Pay no attention to the twencen bourgeois paradigm. Your portals are young and your ideas bountiful. Set them free, free, free!

Best regards,
Gina

Dear Gina:

Yes, yes, and yes! Your advice and glowing perspective is just the ticket we need now. Thank you, Gina! It really works! I had a collector encounter yesterday and successfully managed a good retort. When asked what medium I use, my sculptura implants selected a giddy and gracious reply, which I delivered smoothly: "Gold, pure gold."

Eureka, Gina!
Eternally yours,
Restylene

DEAR
GINA: I am writing to you from behind my desk. It stands in front of a large window – I can see two trees and a block of apartment buildings. My desk is gray. I am telling this so you can picture me writing to you. Perhaps you could do the same for me when you write back. You could describe the room you work in, the view from your window, what you're wearing. I'd appreciate that very much. It would help me feel like I'm having a real conversation with you. If I could picture you, I could imagine we are two strangers who have met by chance and confide in each other. Sometimes it is so much easier to be intimate with a stranger, don't you find?

Also, I think that if I could picture you it would help me tell you what I need to talk about. You see, I have decided to write to you because I have an important confession to make. There is something that weighs heavily on my conscience. I feel the need to get it off my chest.

I didn't pick just anybody, I chose you, Gina. This is not a coincidence. I couldn't tell anybody else; nobody would fully understand except you because my confession involves you. It's for you and about you. And as for your readers, they will be fascinated. Your dear and loyal readers, your fans, we owe it to them.

I look forward to reading your response in next month's issue.

I am,

Your Intimate Stranger

Dear Gina:

I must admit I was a little piqued that you decided

not to publish my letter. I had been looking forward so much to your answer. Reading your problem page in the magazine I never once stopped to think that you must get so many letters that it is simply impossible for you to publish and answer them all.

What a busy woman you must be! And what a strange position you must find yourself in. Just think, all those poor lost souls who have only you to turn to. You are their last hope – they cling to you for guidance and wisdom, like drowning bodies to a raft. The responsibility that rests on your young shoulders must be a burden to you.

I am sorry to be the one to add to your workload; you have to understand that there is not merely a personal interest at stake here. What I have to say not only concerns you and me. I must beg you, do not ignore me. It is vital that you move me to the top of the pile on your desk. You must publish my letters.

Your Intimate Stranger

Dear Gina:

I am really, most terribly disappointed that you have again failed to publish my letter. Surely you realize I will not give you my confession unless you do.

Perhaps I haven't given you enough to go on. Would you like me to tell you a little more about myself? I'm sure you would. I'm curious, Gina, what would you call a real scandal? What would be, in terms of material that sells magazines, your absolute number one, wished-for, dreamed-of confessional letter? I think this is a fascinating subject: we should talk about it at length in our future correspondence.

The thing is, Gina, I need to hear from you before I can go on. I just know you won't be sorry. We have so much to talk about, my dear. Besides the serious matter of my confession, there are many lighthearted subjects we could touch on, delighting in each others' intellect. There is so much I'd like to ask you. About your role as an Agony Aunt, for example: what are your feelings towards the people who write to you? Do you pity them? Do you look upon them as your friends, your children perhaps, to whom you stretch out a guiding hand? Or are they losers who are incapable of running their own lives, morons and geeks who fantasize about you and write to you just to scavenge a scrap of your attention? Is that what you think, Gina? What a harsh judgment. What a cold, mean, and arrogant person you would have to be. Are you laughing at them all the while?

But of course you aren't, are you, Gina? You're a kind person, I know you are. A little blunt perhaps, somewhat unpolished if you like, but good at heart I'm sure. And that's why you're going to answer my letter this time. I will find it in the next issue and everything you write back to me will be delightful.

Your Intimate Stranger

Dear Gina:

You are a stupid fool. It is a terrible mistake on your behalf not to publish my letter again. It is a grave error of judgment. I thought you were smarter than that. I had such high expectations of you, Gina Ashcraft. You have shown me no respect.

Lucky for you I am such a nice person. Lucky for you I am not vindictive or petty, that I am a patient and

understanding person.

I understand, for example, that in my case, you might be a little uncertain. There is nothing to prove I'm not bluffing or bullshitting. I could be anyone – a creep or a stalker, a pervert. Perhaps you are right to be cautious. A woman all alone at her desk, working solidly from dawn till dusk without a moment to glance over her shoulder, vulnerable, defenseless.

So you see, I understand you, Gina. And I forgive you. But I'm not prepared to forget you. In fact, I have decided to help you. Your perception is clearly clouded by caution, but now you must throw caution to the wind. You must surely see a scoop when it is right under your nose. I am sending you a small package along with this letter. You will now open it and recognize its contents instantly. In a flash, you will understand what it is I want to talk to you about. You will proceed to publish my first letter, accompanied by your warm, coaxing response. We will then embark on an exciting exchange to be shared by your breathless readers and we will forget that this letter was ever written.

Your Intimate Stranger

P.S. You must be enormously surprised by the content of the package you have just opened. I wish I could see your face! I do hope I haven't scared you with it, and with the stern tone of my letter. I'm sure you realize now that it was necessary to admonish you. But please be assured that my intentions with you are not dishonorable. I really don't mean to unleash a scandal about you, although of course for commercial reasons it would be profitable to let your readers believe that I would.

Your Intimate Stranger

Dear Gina,

I write this letter with the smallest hope that by some fluke it will find its way into your hands. I know now of the terrible conspiracy that is working against you. I have written to you many times before, but only now do I realize that they have kept my letters from you. The evil powers working against you obviously recognized how crucial I am to you and they are hiding me from you.

I will try to explain. I have been trying to contact you about a matter of the utmost importance. When all my efforts were answered only by silence, I became distraught. I found it impossible to accept that you would be so indifferent and foolish as to simply ignore my letters. I tried everything. Of course, they wouldn't put me through to you, but I didn't give up. At last I managed to speak to one of your editors. Gina, beware of these dangerous and unscrupulous people. They told me many dreadful lies. They tried to sell me a story about there being many editors and authors, but I didn't listen. I believe that you exist, Gina. I know you are out there, I can feel it.

You must confront them now, Gina. You must stand up fearlessly, you must see through the web they are weaving around you, trying to trap you and constrain you.

You have to fight, Gina. There is nothing I can do to help you except try and warn you. But remember that we, your readers and those who confide in you, we are thinking of you and supporting you during every moment of your battle against the fiction of your existence.
Your Intimate Stranger

A Nothing Painter

D<small>EAR</small> **G**<small>INA</small>: My problem is a problem within a problem – compounded by what I suspect are much worse problems. If it were fiction you wouldn't believe it, so let's call it another flaccid nightmare in this comedy we call the art world. And since the situation involves so many levels of problems, I wonder if you could help me construct a kind of architecture of problems so that I might enter and exit with ease.

A rough outline of the situation is as follows: a suburban city decides to launch a summer series on nothingness, during which the ica and thirty-six other cultural groups are meant to address the subject, or lack thereof, in various ways for three months. Imagine this: there is a small university on the outskirts of this peripheral city which you have never heard of but which happens to have a fairly ambitious exhibition program run by a man named Dick. He also is an artist, and I know Dick because I was once a Dick when I was a curator/artist trying to maintain a foothold in the art world. In any case, the university gallery wants to take part in the Nothing-ness series with an exhibition entitled "Open." "Open" will hide artworks (by roughly fifty artists) that are invisible or barely visible, thereby equating visibility with some-thingness and invisibility with nothingness. As Dick explains it, the visitor will walk into an exhibition of about fifty artists and at first see only a white cube. I lightheartedly think, "Oh, that's fun." To my surprise, Dick invites me to come up with a painting for the exhibition because I work with the idea of what is

hidden by the picture plane. A fleeting thought goes through my mind – I hope he understands I can't make my painting really invisible.

After ruminating on it for a bit, I propose a photographic silkscreen based on a picture of the actual gallery wall meeting the floor and then place the painting on the floor in just the same spot. In other words, the viewer sees a painting on the floor leaning against the wall, but the painting pictures its own deflated position as an object, subject not only to gravity, but also to removal. It also pictures what it hides, which is nothing "worth" picturing. The familiar texture of paint over sheetrock and even a roughly plastered-over spot where a nail had been, can, with a little squeezing of the eyeballs, remind one of a Caspar David Friedrich, or a Turneresque marine horizon with a pale planet shape floating in the sky. I liked the idea of the ultimate banality or nothingness of the depicted site coupled with the negating gesture of leaning the painting on the floor, as if it will never reach its desired horizon of the wall. However, in the end my idea negated its own inclusion a little too effectively.

Another problem level was that my own career was increasingly invisible, not having a gallery or any upcoming anything. If all my problems were a house this particular career problem would probably occupy the living room of the problem building. I cynically brooded that even though I knew the exhibition would be unseen in every sense of the word, at least some friends might see the announcement card, which placed me next to Yoko Ono. So I decided to produce

the painting costing, in the end, roughly $1,500 when you combine the cost of the panel, the film, and the silk-screeners. A few days later I get a call from Dick saying that he and the other curator, whom I hadn't met, were not happy with the painting because they expected the painting to really disappear in its own optical illusion. When I heard this, I was emotionally standing in my too-quiet problem living room. The ensuing discussions so comically parodied my own career paranoia that it was positively eerie.

With less than a week before the "Open" opening, the curators hoped a happy solution could be found. I emailed this response: "Dear Curators, Unfortunately I can't seem to think of any happy solutions [I had in the meantime come up with a few that were all rejected,] but maybe an unhappy one could work. It does seem that the content of many works in the exhibition can be gleaned from the checklist. In other words, many of the works seem to communicate their elegibility only by virtue of being explained on the checklist. This said, my contribution can be to the checklist. It can read: 'R.H. Quaytman, *Arcadia*, 2004, silkscreen on wood in bubble wrap.' When a visitor to the exhibition asks where this work is, the curator, guard, or intern can respond, It is not included."

Somehow, this solution seemed to satisfy me because it subtly mocked the checklist and power of the curators and at that moment I felt entitled to a tiny lash-out. Why, I wondered, weren't they telling Liam Gillick that his colored pencil markings on the wall weren't invisible enough, or Robert Gober that his

drains sucked? The obvious answer seemed to be that I myself was invisible and they were not. Had my work been a mirror, or white, or in the form of a written idea, or only visible when you were standing two millimeters away from it, or hiding itself by looking like a non-art object like chewed gum or a tattoo on the guard's arm, it might have had a chance. But instead it was visibly working with the idea of nothingness without resorting to an obsessively painted *trompe l'oeil* kind of gesture. It was irksome to think that had it been a too-visible art object from a too-visible artist, the problem would not have arisen. In any case, the show happened and, as I suspected, I never heard a peep from anyone about it because no one I knew saw it.

About four months after the show closes, I hear from the curator that he is coming to New York and he can return the painting. I say, "Great!" and think let-bygones-be-bygones and, "By the way, when you stop by I can show you the paintings I made this fall for two exhibitions." He wants to talk about the catalog because every artist gets a page. He says they thought of photographing the painting in bubble wrap, but didn't have time. I say, "Oh well, I think I will just hang that painting in my studio and take a digital picture of it and you can use that." But no, he doesn't like this idea either for some reason. I just want to scream, "Show my fucking goddamn painting!"

But I know I can't do that because . . . well, Gina, can I say that? Oh, by the way, when he comes to drop the painting off he just hands it to me at the elevator and then hurriedly leaves without even the

slightest curiosity about work I've made since. I'm sure he has his own completely different perspective on the whole thing – but should I and do I want to, need to, or am I impelled to worry about his perspective? I mean, Gina, artist or curator – which is better? I mean, isn't there just a tiny bit of hierarchy left in this world, even if as an artist no one sees you?

Sincerely yours,

A Nothing Painter

Ich bin von Montag, den 19.12.2005 bis einschließlich Donnerstag 5.1.2006 nicht in der Kunstakademie und werde während dieser Zeit meine E-mails nicht lesen. Sie können sich in dringenden Fällen an meine Assistentin U.R. Onyurown wenden: Tel. +49 89 211 27 123.

I am out of my office from Monday, December 19, 2005 until Thursday, January 5, 2006 and I will not be checking my e-mails. In urgent cases please don't hesitate to contact my personal assistant U.R. Onyurown: Tel. +49 89 211 27 123.

D<small>EAR</small>
G<small>INA</small>: Most artists have very little security. That they may survive another day and continue their work, some take on menial jobs as waitresses, waiters, and bartenders, while others get caught up in being assistants to those who have already found some semblance of success. There are a huge number of us. Sometimes we sit and file, and behave haughtily or prettily, on the front desks of galleries, and sometimes we are the lackeys who hang the next show after packing up the last show, filling holes, plastering, sanding, painting, unpacking, and waiting endlessly while decisions are made, decisions that we are considered too dull to comprehend, much less to resolve.

Still others work on the archives, or the personal correspondence of the famous. One woman I know prides herself on being the accountant to three equally famous artists. These artists dislike each other intensely, so this woman plays with a small feeling of power by reporting tidbits about one to the others. She is clever and inclusive, and when she tells someone something about someone else, that someone really feels that they are a special someone. This woman implies that this information is for this someone, and for this someone alone! An intimacy is quickly established when shared information is so special, so carefully chosen, and so carefully exchanged. The woman is a former painter. Her regular job and regular pay, and her eventual degree in accountancy which came after her degree in bookkeeping, seemed to give her more access to the successful and wealthy than her

paintings ever did. Her loft space is no longer a studio, but a glossy and oft-photographed home. But I digress!

My own method of survival has been to fabricate the works of other artists. I work well, and precisely, and I like being able to stay in my own studio workshop while I am following complex plans and drawings with exactitude. I can make myself innumerable cups of tea, and I can take long breaks sitting and reading on the loo. I like to read on the loo. Some days, I think that my mind is more open and receptive as I sit there with my bowels open and my system at ease. I can read for hours sitting there. The only thing that stops me from reading all day is that the light is not great. I must restrain myself from screwing in a bulb of stronger wattage. With better light, the only thing that would drive me back out into the studio would be the need for another cup of tea. In short, I am free, even while working for others. But again, I digress!

My dilemma, my reason for writing to you is complex. About eighteen months ago, I moved my studio to yet another mixed light-industrial/dilapidated residential neighborhood. Here I have good space. I have dry floors, good light, high ceilings, adequate storage, hot and cold water. In fact, I have all a working artist could want! And I have all of this at a very reasonable rent. It all conspires to make me a very happy and slightly smug artist!

In the back room of the space, the previous tenants had left an ancient band saw. They said it was just too heavy to move. As it was still in good working order, I

was happy enough to have it. These tenants had run a business called Forget-Me-Not. In the front part of the space, which has walk-in access off the street, they ran a funeral parlor for pets. In the rear was the band saw, which they used to make the coffins.

I was amused and not uninterested in the whole operation, and in the twenty-two year history of the workshop. I got a fair bit of mileage from describing it to people at parties and openings. The painted letters of the name were still visible over the door, lovely peeling blue letters on a soft greenish-grey background. It had been a tasteful, yet sweet, color decision those many years ago.

As my own work and activities filled the space, I gradually forgot about it all, except to direct people on how to find me by describing the peeling pale blue letters of Forget-Me-Not, so discreetly visible on my grim and drab street. You think I am digressing again, but bear with me. I will make my problem clear.

One wet Saturday as I was working away, my doorbell rang, and I opened the door to find an elderly woman standing on the pavement with a cardboard box in her arms and tears streaming down her cheeks. She held the box out toward me and said the word, "Miriam." The simple utterance of this single word served to release huge noisy sobs from the elderly lady. It took me some moments to understand what was happening. As soon as I did, I gently drew the woman in out of the soft drizzle and explained to her that this was no longer Forget-me-Not. It was no longer a funeral parlor for pets, I said, and she would have to take Miriam elsewhere. "But where?" she wailed.

Nearly blind and living just down the block, she had little awareness of the rest of the neighborhood, and even less of the larger city. And with her eyes, the Yellow Pages were certainly not an option.

After brewing a pot of strong tea and handing over innumerable tissues, I calmed the dear lady. She recounted some of Miriam's more endearing moments, and we chuckled sadly together. I did wish I had some biscuits to offer her, but instead I volunteered to make a small coffin for Miriam, the ancient and beloved tabby, and to arrange for her removal. Indeed, what else could I do?

The next afternoon, I collected Mrs. Barton (for that was the poor widowed lady's name) at her apartment, and drove her and Miriam to the far reaches of a local park. This park is a park in name only. It is more honestly called a rubbish dump, with the litter off the nearby highway and the detritus of apartment dwellers and environmentally naughty local light industries scattered about. Here and there the suggestion of winding paths and ragged trees make visible what the park once was. A few scruffy green bush-like things have survived, but certainly not because of help from any humans. In addition to the few sad bits of vegetation, there are a lot of tires and rusted washing machines. Used condoms, food wrappers, newspapers, and bits of torn clothing squish and slip underfoot.

Mrs. Barton's eyes were so poor that she didn't notice how wretched it all was. She didn't notice that my only tool for digging was an old and dented aluminum snow shovel which barely functioned in the dry hard soil.

She did, however, notice my black clothes, and thanked me repeatedly for my show of respect to poor Miriam. After the burial, I dropped her at her apartment, refusing any payment, and returned to work on my important commission.

Within a few months, I had made another twelve coffins. Their occupants included a dachshund, various cats, a turtle, twin hamsters, an Alsatian, a few mongrels, and a parakeet. Word was out, and, reluctantly, I was in business.

Over these months various curators, artist friends, and collectors noted my little sideline with amusement. It became a bit of a talking point when I went to openings and parties. At first it was fun, but I began to wish someone would ask about my new work.

One evening I received a phone call from an influential collector who was very eager to see me immediately and privately. As I awaited his arrival, I could barely contain my excitement. Would this be my big break? Would this be a turning point? I could scarcely wait for the posh car to arrive on my street. Instead of a great exhibition offer, a fine commission, or a huge sale, I was asked to make a very special coffin for his deceased and dearly loved Corgi named Giotto. (I shall keep the collector's name to myself!)

One might think that a few coffins made of scrap wood for elderly neighbors might not be such a big deal, but after Giotto's custom coffin and the motorcade and his burial on the grounds of a large and lovely estate, the orders have been coming in fast and furiously. The materials are increasingly special, both inside and out. I have hired a young Polish woman to

line and pad the interiors with soft and sumptuous fabrics whenever requested.

The art world is lining up at my door! Quite regularly, I am flown to Italy, France, Montana, or to the Orkney Islands to assist in laying poor Beelow, or Topsy, or Darren, or Fern, to rest. My black clothes are more expensive, and of course I have someone else do the digging. On these occasions my appearance is never complete without a forget-me-not in my lapel. I have sourced a reliable and regular supply of fresh blossoms. I also have some very beautiful fabric versions of the flower, which are handmade for me in Limoges. These artificial blossoms are invaluable for those times when the real thing might not travel well. It is essential that I always arrive looking good, no matter how long my journey with the deceased. My inclusion at the best dinner tables is expected (both by me and my hosts), and my discretion and gentle manner are widely admired.

Forget-Me-Not is a booming business. Yes, of course I kept the name, and the sign has not been re-painted. To repaint the sign might imply that I am in this business too seriously, too commercially, that I do this pet funeral business for just any old person, rather than for the chosen few who know how to find me, and who can afford my services. Of course, I do do this service for any old person. My neighborhood contacts are dear to me. I have even been inquiring about purchasing a small plot of land on which to create a proper pet graveyard for the many city dwellers (artists included!) who have no land of their own in which to bury their beloved pet. I have drawn

extensive plans for proper landscaping, fencing, and stone carvings.

My dilemma, dear Gina, is: what should I do? No one is interested in my art any longer. If I give up the business and go back to my art, will any of these people pay attention to me anymore? Will I be invited to any more dinners? Will they kiss me hello and still call me the Prince of Pets? Will they kiss me goodbye and still call me the Prince of Pets?

To be truthful, I don't like *all* of these people. A great many of them are a bit stupid; some of them are dull; some just need to feel needed, that they are the ones in a position to give. On the whole, I find the food fabulous, and I can't bear to think of giving up the great wines.

And there's a great deal more travel I would like to do. I have been keeping a close eye on an elderly white poodle called Gesso, who hasn't long to go. In fact, we have already done Gesso's measurements, and the family crypt at Zermatt is ready whenever we are. How I long for the mountains at this time of year!

If I give up the art, my art, and live on as the Prince of Pets, am I any better than the lady accountant about whom I have always been so disparaging? Have I become her in my vicarious participation of the art world as we know it?

Advise me, please. My nights are sleepless, and my days simply too busy to stop for long enough to sort out my future.

Respectfully yours,

P.P.

Dear Prince of Pets:

Your course is set. Don't be such a pillock. The expression "Don't give up the day job," was invented for the likes of you!

You used to make works for other artists and now you are burying the pets of rich people. From where I sit, the level of compromise doesn't seem so huge. At least your job perks now include world travel and fine food and wines. I assume you are not traveling on budget airlines? (Do you carry little Poppet or Henry with you in the cabin, or do you place her/him in with the checked baggage?)

If you have the time and inclination, you have no need to stop making your work. Since you never told me what it is, I can't comment on whether it's worth your while to continue, nor if the world needs any more of it, but "a nice little painting by the dear fellow who buried our Trixie" will probably become as much of a collector's item as you yourself are. I mean, how many people have an undertaker at their dinner table?

Gina

D^{EAR}

G_{INA}: I have been a security guard at a major art museum for over ten years. I used to love my job, but a few years into the work, perhaps out of boredom, I developed the habit of secretly touching the art works. I discovered that doing so gave me an indescribable sense of power and freedom. At first, I would just caress the Mondrians and the Légers when no one was looking. Later, though, I started being more audacious and began to make minimal alterations to the pieces – taking a minuscule particle off a painting, scratching a sculpture, making a mark with my nails, etc. At this time, I believe I have slightly altered virtually every artwork in the museum's permanent collection, and I even have a diary that details, very precisely, the date and type of modification. But, I am a bit worried about being caught. Recently, I was fooling around with a Kiefer and accidentally ripped off a piece of charcoal (although no one has noticed yet). On another occasion I was almost caught, but fortunately was able to accuse a visitor of the alteration. Am I turning into an artist?
Artistic Guard

Dear Artistic Guard:

You certainly have artistic instincts. You have turned the museum's works into found objects and you are making them yours by virtue of your slight alterations. At this point what has really happened is that due to your artistic interventions in the works, they no longer belong to their original authors anymore, they have ceased to be the pieces that they originally

were. Now they are, at best, collaborations between them and you. There are three courses of action open to you at this point: one, you disclose what you have done to the museum's administration and everyone else. If in fact your alterations have improved the pieces and this is acknowledged, you would have the chance to be recognized as an artist and maybe even make the institution change the authorship of the pieces in its collection. This option, however, I consider highly unlikely: even if your alterations are magnificent, they aren't likely to be understood by the museum's curators (they normally don't understand anything processed by the art or theory market anyway). This brings me to the second option: you disclose your actions, get fired, and face legal charges. It goes without saying that this is perhaps not the most convenient for you. The third option, which is the one I recommend, is that you keep silent, continue doing your (art)work, and keep good records of your artistic activities. After you die and your diary is found, art history may redeem you.

Gina

Conflicted Curator

DEAR
GINA: I am not an artist, but in reading the note from Bitter Professor a few weeks ago I thought I would really benefit from your advice. I am a curator of contemporary art at one of the leading museums in the world. There are very few people in my position, and I had, until recently, quite strong taste-making power – if I invited an artist to show or purchased an artwork, this artist immediately ascended to stardom in the art world. At first I thought that doing this was a lot of fun, and I didn't feel accountable for my decisions. One day, a museum trustee started pressuring me to do a show with a group of really bad artists. I knew that if I didn't do it I would lose my raise and the chance to curate a major biennial. So I thought, why not? I did the show. As a result, the show triggered a trend of bad painting everywhere, supposedly sanctioned by me.

Now I am tired of this monster that I have created and feel that I can't say anything about the eyesore of paintings I see sprouting up everywhere. I tried to counter this trend by doing another show with artists whom I consider truly fine and relevant. But now I don't seem to be able to convince anyone, and those who applauded my selection of the bad painters now say I am "out of touch" with what really is happening out there. The art world is increasingly interested in the bad artists I selected. Should I just continue supporting those bad artists, or confess my true thinking and be put in disgrace?
Conflicted Curator

Conflicted Curator

Dear Conflicted Curator:

The curator's medium is a group of artists, and when you selected that group you were creating an artwork that now belongs to the public realm, not to you. But you stumbled into a critical issue that is rarely discussed: firstly, the public really doesn't know anything, they are just waiting to be told what to like. Secondly, bad art is really easy to like, and good art is much harder. So it is naturally very hard for you first to offer an attractive but cheap dish to the public, and then try to force-feed them with what is really an acquired taste. Who would like to eat frog legs after having had a cheeseburger, especially if you have convinced everyone that both things are equally healthy and elegant?

Gina

DEAR
GINA: I always thought that my friend was a very radical artist: his work consisted of doing nothing – absolutely nothing. He wouldn't even write a letter to you discussing his artistic practice. He doesn't propose any projects, doesn't have any old or new ideas to communicate, doesn't make anything, promote anything, talk to anyone in the art world, or go to any art openings. He doesn't talk about his art or write about it, and has never done a show. I thought he was the most dedicated and committed artist I had ever known, and I considered his to be the most eloquent, conclusive, radical, and consistent statement about the exhaustion of modernism. I became so fascinated by his case that over the years I took it upon myself to become his historian, biographer, dealer, and main promoter. I gave lectures about him, discussed the implications of nothingness in contemporary art, and debated the importance of his art for our time. As a result, my efforts bore fruit and now my friend has got a lot of attention. Having nothing to buy, collectors just send him checks. Having nothing to show, museums just automatically add him to their collections, under the logic (that I myself constructed) that it is for them to say if he is included in their collections or not. Other imitators have emerged around the world, but never with the same charisma. He is debated in symposia, magazines, and universities the world over and in many events to which I am generally invited. Given what I have just told you, you may imagine my dismay when I brought my friend a copy

of *Artforum*, showing him on the cover with the heading "The New, and Last, Duchamp," and he said, "What do you mean? I am not an artist!" I had never asked him that question because I had thought it would have gone against his rule of not speaking about his art. I now realize that the one who has constructed an entire career on nothing has not been him, but me. Should I just continue maintaining this fiction or what?

Minimalist Theorist

Dear Minimalist Theorist:

I think that you may have failed to appreciate the evolution of your friend's work into a second creative phase, which consists of negating that he is an artist. Let's say that he went from a Duchampian to a Magrittian state. You should read his negation as a new phenomenon that will undoubtedly prompt many more fascinating philosophical discussions, many complex articles, heated debates – and, of course, the arrival of more checks.

Gina

Dear Gina:

Following your advice from a few weeks ago, I went back to my friend and informed him that I would continue writing about him, but in his new creative phase of being a non-artist. He didn't seem to take it very well and continued trying to convince me that he really didn't have the slightest intention of being an artist – or a non-artist – whatsoever. Nevertheless, I took his response as an affirmation that he would indeed continue his resolve of negating his

artist-hood. After I published my article on the new phase of my friend, there was a huge reaction from the art world. Some hailed a new era in art. New symposia have been organized (as you predicted) and yes, more checks have arrived. Now the problem is that with all the money my friend has made he is suing me for defamation, as he claims that he is neither an artist nor a non-artist. What do I do now?

Minimalist Theorist

Dear Minimalist Theorist:

Looks to me like your friend is trying out one of his tricky non-artworks on you. But you can point to this contradiction by counter-suing him for cashing the checks from collectors. If indeed he claims that he is neither an artist nor a non-artist, his cashing of the checks in exchange for the service that he purportedly negates is illegal, because the collectors were purchasing goods that didn't exist. If this trial is indeed a non-artwork, your friend would be forced to drop the charges, because that would prove that he is indeed an artist/non-artist. And if he indeed is neither of those things, he will have to pay back all the revenue he has accumulated. So you have nothing to worry about.

Gina

Dear Gina:

You should know that I went to trial with my friend, and things turned out ugly. In order to prevent the possible devaluation of many powerful collectors' investment in my friend, Art Basel Miami offered to finance his legal costs for the trial. The court determined that he indeed wasn't an artist or an artist posing as a

non-artist, which meant that I needed to recant all my statements about him and pay him an incalculable sum in damages. Once the verdict was over, and the case was heavily publicized, my friend claimed that he would start making artwork, and soon after started working with Deitch Projects. He got to keep all the collectors' checks, and still figures in the collections of the best museums in the world, as the art world determined that even if it wasn't intentional, the fiction of his non-artist-hood was worth keeping for good. In all, looks like he kept all the money, all the credit, and I am now facing jail time.

Minimalist Theorist

Dear Minimalist Theorist:

Sorry to hear about your situation. Unfortunately, this is what happens when you write art history or criticism: as much as you try to appropriate the artwork, in the end, the one who prevails is the artist. I really suggest that once you complete your time, you try to pursue a career as a non-art historian.

Gina

Hitman Critic

DEAR **G**INA: I am an art critic. One day I was feeling very sick and irritable and thus wrote the most scathing review of an artist's exhibition; shortly after that, the artist committed suicide. By most accounts, it was because of that review. It was an excessive reaction, but I was impressed by the power of my writing. I wasn't the only one who noticed the effect of my review: one day, a shady individual made an appointment with me and offered me a large sum of money to write negatively and repeatedly about a certain artist who he disliked and whose career he wanted sabotaged. He discreetly bought me space in most major magazines and newspapers to write about his victim's show under different names. Our negative marketing campaign was so effective that within one year this artist's career was in serious trouble; in two years the artist had pretty much stopped producing and moved into graphic design. After that, I have had many more "commissions," and according to my calculations I have ended around fifty-nine art careers, sent quite a few artists into therapy, caused one to convert to Hari Krishna, and yes, I have caused a few more deaths. Is what I am doing considered legal?
Hitman Critic

Auntie Gina's response to Hitman Critic has been censored from this publication by order of the FBI. The case is currently under investigation and detailed surveillance of contemporary art critics is being conducted to investigate links between them and terrorist cells in this country. – Eds.

DEAR **G**INA: I am the chief editor of one of the most powerful art publications around. I fell madly in love with a man and am extremely happy with him. The problem is that he is a really bad painter and he doesn't know it (nor do I have the guts to tell him, because he would be devastated). This has created all sorts of awkward social situations for me, as I constantly attend very high-level events at top art museums and art-collecting events, and he comes with me. People in the art world try to be discreet about it, but I know very well that everyone is horrified that I could be with such a bad artist. I also have noticed that some of them have even started to question my aesthetic taste based on my relationship choice. On top of that, my partner naturally expects me to support his career and invite my high-level contacts to his openings. I feel trapped and don't know what to do. Can you help?

Torn Editor

Dear Torn Editor:

I am sorry to say there is no solution. You broke the golden rule of the art world, which is to not sleep with someone whose artwork you don't like. Love and art are, unfortunately, incompatible. Did you ever think you could have everything?

Gina

D<small>EAR</small> G<small>INA</small>: I know you usually only answer artists' problems in your column, but I'm hoping I can rely on your generosity to answer a question from an art critic; the subject is surely something of interest to us all: art and love. I had to overcome a lot of resistance to present my problem in the public domain of your agony column, even though it is a famous and highly intellectual art magazine. What made me finally decide to send this letter is a rather vague but persistent feeling that a painful personal experience of mine has wider and more general implications.

I am a writer, an art critic. Over the years, I've published a number of essays in magazines, catalogs, and newspapers. With few exceptions I only wrote about the art which I really love, not to praise it, but rather because only when I truly loved something did it seem worthwhile to me to make the effort in gaining more insight, knowledge, and understanding.

Recently a ghost from the past returned, bringing back painful memories. A few years ago, I planned to write a text for a young artist whom I knew (and still know) very well and in whose work I sensed an element of concavity that I recognized from my own life. Initially he felt honored, thrilled even, and was eager to co-operate. We had many talks which focused on his work and I started making all kinds of preparatory notes. But then, without me knowing why, his enthusiasm waned and he seemed to lose all interest in the project. He hardly responded anymore to telephone calls, faxes, or specific requests. And gradually

the whole project bled to death. Angry, hurt, and frustrated, I put away all the preparatory stuff and wrote him a long letter just to ask: why?

Surprisingly, he responded quickly and wrote that at first he was indeed very enthusiastic about the project, but that I couldn't imagine how disappointed he was to find that I loved him. His frequent evasions, he continued, were more or less meant to disappoint me, to deflate the intensity of my feelings and to make our special collaboration a drab and mediocre association. He added that writing this sounded absurd to him, but nevertheless he thought it could be true.

This answer came as a complete surprise to me. I had never suspected nor anticipated that my love could be a barrier that disqualified me from writing about his work. Apparently, he thought that I only wanted to write about his work, not because of the work itself, but because of him. While I was convinced (and still am) that my feelings for him could only increase my insight, knowledge, and understanding, he seemed to believe that it would make me blind, or at least would compromise my objectivity and critical abilities.

Quite recently, three years after the events described above, he cautiously sounded me out: would I still be prepared to write something about his work? I don't know what to do. Was it a terrible mistake at the time to propose to write a text for him? Do you think that writing about an artist's work is totally incompatible with loving the person? Gina, what do you think? And what shall I do?

Disappointed Art Critic

Disappointed Art Critic

Dear Disappointed Art Critic:

On occasion, readers have expressed their uneasiness with my often-contradictory opinions and changing stand-point within these pages.

Well, if the truth be known – and now it will! – this is because I get most of my arguments and answers from various experienced and knowledgeable sources, in fact different sources collected within one specific volume. For "answers" to my readers' questions and problems, I always refer to the bastion of truth and guidance that is Art in Theory 1900–1990, An Anthology of Changing Ideas *(Charles Harrison and Paul Wood, eds., 1992).*

It's within this book that I've found the answer to many a wide-ranging dilemma and query regarding contemporary art discussion. So when your problem of love and art arrived on my desk my first instinct was to reach for my bible to see what insight I could gain from within its well-thumbed (and very thin) pages.

"To be truly immortal a work of art must escape all human limits: logic and common sense will only interfere," wrote de Chirico (ca 1915, p. 60). I took note of this, as it seemed appropriate for three other pieces I'm working on, but not quite specific enough to help in your particular case. So I moved on to another text in the book, which on the surface looked promising.

Jackson Pollock's "Answers to a Questionnaire" (p. 560) seemed encouraging at first, yet alas, there was no mention of love there.

On page 563, Mark Rothko writes about what prompted the Romantic Movement, though once again there was nothing about love in it.

Artaud and Camus gave me no useful insight on the

subjects of trust, sincerity, friendship, or love within the art world, despite all the answers they have provided me with in the past.

One of David Sylvester's many interviews with Francis Bacon adorns pages 625–629. At that point I found I was already halfway through my book, yet no closer to finding anything I could use for an answer. As time passed into the night, all I found was discussion of the "modern condition" and the aloneness of the human individual, which really wasn't helping matters at all.

Claes Oldenburg (p. 727) was for an art "that imitates the human, that is comic, if necessary, or violent or whatever necessary." I always get a kick out of reading that particular text in its entirety, especially out loud to myself when intoxicated, and I contemplated a way of using that quote, as in some indirect way it could have been valid. Though I crossed out my note of how he was also "for an art that spills out of an old man's purse when he is bounced off a passing fender," as it wasn't especially suitable. I started to wonder if giving advice on personal problems in a public forum was indeed something that I was actually cut out to do.

By this time, I was in the late 1960s. I felt dazed; the previous six decades of art writing had taken its toll on me. I was tired; the pages were getting increasingly difficult to read and their meaning difficult to comprehend. Or was that just writing on 1960s conceptual art? This was supposed to be the summer of love, after all, so I hoped the art world would have reflected this and I could perhaps find here an article to help you.

Sol LeWitt offered me a list of easy-to-digest sentences on conceptual art (p. 837) and my brain heaved a sigh of relief. By now I had started to overlook the specifics of your case and

instead chose to answer in a more open-ended and general way. I noted down two of LeWitt's sentences, which I could perhaps use:

#5. Irrational thoughts should be followed absolutely and logically.

#32. Banal ideas cannot be rescued by beautiful execution.

Lists seem(ed) to be popular among artists who write, so I consulted the contents for more, hoping that someone had hit upon something that would point me in the direction of answering your problem.

Nothing.

As desperation set in I decided to check the index to find anything concerning art and love. But all I found was Art and Language on page 873.

Art and Language artist Ian Burns's text concerned the art market. I had hoped to find somewhere in there a mention of the relationships between critics and artists, but it just turned into another essay regarding alienation.

So I pressed on with my task: Foucault, Barthes, Kristeva, Judd, Richter, Baudrillard, Halley, Koons, Derrida. . . .

Isolation, disenchantment, dissatisfaction, and disillusionment seem to characterize a lot of art writing, not love for people. And perhaps your letter to me will be the only result of your collaboration with this artist and maybe it says everything you want to say, just in a different way. As to why I couldn't find a solution to your problem in my book, I can only conclude that your problem concerning art and love precedes 1900 and is therefore not covered by my book.

Gina

P.S. I did try to put a few of my own notes together to produce some kind of tentative answer, yet they seemed like a

contradictory, incoherent, soulless textbook answer. It would take many more dawns before working it out completely, but for reference I've listed them here.

Is it possible for a reader to question the critical parts of a text if the author might have ulterior motives, or simply dismiss a text written by a lover that seems too favorable?

Is the problem exacerbated due to the perception of "ulterior motives" (or maybe just the latent fear of them)?

Is it not rather a case of the more one understands a subject the more passionate you are about it, or is it – as in your case – the other way around?

Is love blinding?

Does someone become perfect when we fall in love with him or her? Do we really only find in them what is most desirable? We never accept all the plans of our lovers, do we?

Can one still objectively judge a lover, or does one use a different scale or standard to judge them?

Should a writer have to declare himself or herself in love with someone whom they write about, or would that make it too easy for a reader to claim that they can see through the text?

Do we have to transgress from the norm to love?

If you propose a project to someone and they say "perhaps another time," you take offense and now neither of you want to do it. Disillusionment first turns to anger and bitterness on one side, then both.

On other relationships between professionals doing this and that for each other for reasons of admiration, friendship, sex, mere goodwill, and love: if one disqualifies all actions in relationships due to their apparent motives, what would there be left to accept as benign or true?

How did he first find out that you loved him? Maybe

that was reason alone for him to distance himself?

Betrayal of friendship and trust? He may have wondered what the motives were behind the friendship and collaboration.

Maybe the problem is not that he didn't want a lover to write about him, but rather he didn't want a lover?

Did he know you loved him before you proposed a text?

Dear Gina:

Somehow you must have anticipated that in spite of my work as an art critic I never scanned, as you did, Harrison & Wood (or any other textbook) on matters of art and love. Seeing you thumbing through your 1,100-page bible and finding yourself finding nothing really moves me. I can imagine that the negative result of your elaborate textbook research must have been as revealing for you as it is for me.

Could it be that our standard source books on art and art theory are all specifically male-composed and male-directed (though probably without being aware of it)? Is it conceivable that another type of textbook, edited by women and using material from different sources, not the officially sanctioned ones, would shed new light on the topic? Isn't it significant that a dear friend of mine, a female artist, pointed out to me a short statement by Picasso (quoted in a remarkably short chapter in Dore Ashton's *Picasso on Art*): "In the end there is only love. However it may be." And finally, dear Gina, could it be that you are male like myself, that you are a man in disguise like "Miss Lonelyhearts" in Nathaniel West's famous agony aunt novel?

After having read your sharp, crystalline account of your textbook work and having smiled (or rather grinned) at your witty conclusion that my problem concerning art and love must predate 1900, I got lost in the labyrinth of your notes of reference; notes you didn't know how to put together without losing soul, though I feel soul in each of your questions and remarks. Thus my "simple problem" concerning art and love elegantly returned to my own desk, like a boomerang.

I am of course not unaware of the intricacies of love, of all its possible pitfalls or ulterior motives, its often socially conditioned faces and masks of power. But however justified your questions may be, I think I can state that none of them played any role in my problem.

He knew I loved him because I told him so. A year later when I proposed to write a text he reacted spontaneously with: Yes! But apparently he had second thoughts, which made him change his mind. I didn't feel uneasy or insecure at all about my motive to write about his work. If "motive" should be defined as "that which cannot be reduced to something else," my only motive then was to transform the pain and locked-up energy of unrequited love into the best text possible. The extra motivation and attention of love could, I thought (and still think now) only add deeper and more meaningful dimensions. It may be obvious that love in itself is no guarantee for a good text, but without love it seems to me there's no guarantee at all.

According to the conventions of the genre I reluctantly signed my letter to you "Disappointed Art Critic."

Skating on thin ice in the twilight zone between the private and the public, I would have rather preferred to leave my letter unsigned altogether . . . thus running the risk of not receiving a reply.

But on seeing myself addressed as "Dear Disappointed Art Critic," I knew immediately that I had made a mistake. The first thought that went through my mind was: it's not as an art critic that I'm disappointed, but rather as a human being!

Keeping this conclusion in mind, I started writing my reply. But something continued to bother me, though I couldn't figure out what it was.

Struggling to cast my confused feelings, I felt the irresistible need to listen to music all the time. So I played Johnny Cash over and over again (just as I listened to the bittersweet love songs of Slim Whitman while writing my first letter to you). But wasn't it Plato (to bring him in for a proper perspective) who said, "Only music knows how to find the most hidden corners of the human heart"?

Actually, at the last minute, when I arrived at my preset "conclusion," I sharply realized that I had almost fallen victim, not to a pitfall of love, but to one of the many pitfalls of language. Having put all emphasis on "not disappointed *as an art critic*," I forgot about the much more complicated reality of human beings. "Art critic" and "human being" aren't equal or comparable entities at all. Although I don't want to deny a painful experience, I'm neither disappointed as an art critic, nor as a human being.

"In the end there is only love. However it may be." Love, like all passions, may have many faces. But

if we call love blinding in advance, then what should we have to think of hate?

The tombstone of the much honored and decorated American Vietnam soldier, Leonard Matlovich, who happened to be gay, bears the sad yet beautiful inscription, "They gave me medals for killing men, but a discharge for loving men."

Well, dear Gina, thank you for your reply. In a very particular way your answer has helped me to re-inforce my beliefs and my trust in love, however painful . . . and however it may be.

I think you know what I mean.

Your "Disappointed Art Critic"

Dear Gina: I'm a fifty-seven-year-old artist, and for the last twenty-five years I've been engaged in performance art, especially focusing on the voice. So, as you can see, I'm not short of experience in this area; my best known works are a series of performances executed in the 1970s, called "indifferent in matter," in which, hidden under a desk, I invented and performed "conversations" between the different objects placed on the desk. Paperweights, letter-openers, pens, papers, desk lamps, and other undefined objects – which I created – spoke about current topics. I functioned as a sort of conceptual ventriloquist. Combining my vocal skills with scripts, these objects were brought to life before the audience: I animated them with my voice. A world of fiction was created through my different characters – and different voices.

I don't know if you have seen any of my performances . . . although I've continued to work in the art world – still employing the mysterious power of vocal animation – I've had to pay my way largely through jobs in dubbing, documentary narration, or using another of my talents: tarot card reading. I get calls relayed through an agency from people who want their cards read. So with the cards and my voice I delve into the lives and fortunes of others, echoing what they want to hear . . . but, to be honest, I only enjoy reading the cards to my enemies – it's really my only pleasure.

My problem began with one of these calls. About a year ago, one afternoon beside the phone, fed up

and poor, anxious for it to ring – I say fed up in the sense of how boring it can get when you know by heart the questions, "Am I going to get married?" or "Is the guy I met the other week the same one I was told about by the woman who read my cards the last time at this number?" or "Am I going to get that job I interviewed for?" And then they get annoyed if you tell them the truth: I don't see any man in the cards, but I see, aaaahhhh, and then they hang up leaving you in the lurch; besides, we get paid by the minute and you really need to get long-winded or you'll never make anything.

But then it happened. The phone rang, and the client gave me his personal details in a timid voice, denoting a certain nervousness and respectfulness: Greg from Boston, twenty-nine years old. His voice was soft, sweet; straight off, I was charmed, and in a weird way I felt challenged and wanted to charm him. I decided to perk up the afternoon, and my purse. So I went on the attack: lending a velvet touch to my words, describing the beauty of his cards (which really were beautiful), whistling softly at the end of sentences. All stops out, I played it to the limit. It wasn't exactly an easy task either, as he had no questions that he needed the cards to answer. Love? "Nothing on the horizon." In that case why ask? Career? As he was a top-grade engineering student, he wasn't particularly worried. Past? At twenty-nine years of age, there had been no major dramas, no ruptures in his life . . . and it was about that which we spoke: life, his and some of mine. As we we're finishing he asked me what days I was on call – it was clear he would call again.

It's difficult to imagine, but we spoke for at least one-and-a-half hours on that first call, and after hanging up, I felt exhausted and relaxed, similar to how people feel after sweating it out at their chosen sport, though at the same time I did manage to get through half a pack of cigarettes. I was nervous as hell and excited.

I called my friends Serge and Peter and asked them if I could call round; I had to tell them. I got in the car and went over to their place, and, as always, they listened and offered that I stay so as not to have to drive home at such a late hour and after a few glasses of wine. They followed my story with kindness and shared my excitement, but thought that it wouldn't lead to anything. However, I knew that something was astir, and that Greg was going to enter my life.

And so it happened. Greg called again, and after two marvelous conversations, I gave him my home number, which goes totally against the company rules – for our safety, they claim. They must think we're completely stupid; the only thing they think about is how better to exploit us. Gina, you know well how we artists are constantly exploited. I thought, they can go to hell, and it was clear Greg would not be calling for any tarot sessions, and he was not a threat to me. So began our telephone relationship.

It was incredible, at my age having a guy of twenty-nine years interested in me. I charmed him, bewitched him. Although, I have to admit, not without using this weapon I know so well how to use. I rehearsed a voice that was both elegant and intimate, confident but relaxed, allowing him to hear my

breathing and feel a certain closeness, and occasionally breathing out just slightly faster than usual, exciting myself, sensing his nervousness.

After six months of telephone calls, we exchanged addresses, though more from his eagerness to receive a photo of me than any initial desire to write. What a nightmare! It was as if everything suddenly fell apart. Why does he want to see me? He hears me every day! It was as if the main issue in my artistic career was out to ruin my little piece of joy: obsession with the visual, with the object, the damned photo. I was disarmed at my fifty-seven years. The fictional Ingrid, who I had created through my voice, she who had caused Greg to fall in love, and she who felt alive, and maybe also in love, needed now not only a voice but an image. I considered not answering, just cutting off all communication without so much as a word of explanation. But I couldn't.

The whole thing gave me a great sense of life, too much to stop now, and in any case, I had been honest about my age from the beginning, and clearly it was part of the flirtation, yet seeing was another story. Anyway, it's not as if a photo would shock him. Serge and Peter helped me pick one out. Serge is a producer of documentaries and erotic stories; he knows what people like. He has known me well for thirty years, and together with his boyfriend Peter, has followed this romance from the beginning. You can't imagine how I rely on both of them; they are the only people I can talk to about this. Every other person I've tried to speak to – artist friends – just looked at me, condescending, unbelieving, disbelieving, and with pity, and

generally showed little interest in my story. In a joking
tone so as to hide my concern, I suggested to Greg we
could send each other a photo at the same time; it
would be like meeting, we would receive the letter at
the same time, and we would look at the photo know-
ing the other was doing the same. This idea helped me
overcome the dread that possessed me at what might
happen on his seeing my photo.

Amazingly, the post worked just as it should, and
we received the letters at the same time, and on seeing
his photo I forgot about my fears: Greg's beauty
knocked me out. He was beautiful. Good body, green
eyes, short curly hair. And I, who have always had
balding lovers – with my black hair now graying and
becoming finer – I am faced with a suitor with thick
black hair. He also sent me photos of his house and
garden – sweet of him!

As the appointed time for our call got closer, I
started getting nervous, and with a copy of the photo
I sent to him before me, I examined it and went
through voice registers that fit with the photo, this
photo that I now had to bring to life. My voice had to
emerge from that image. The Ingrid who was warm,
sure of herself, and somewhat adventurous, who had
been talking for six months, had now to continue act-
ing in the light of that image: dark eyes, hair dyed
black, wrinkles here and there, and a bit wide for her
age. Not that I was bad looking, but alongside the
women a guy of twenty-nine might have. . . . Despite
my fears, the phone rang at the given hour. Greg's
voice greeted me with emotion, deep and calm, and
he said I was as beautiful as he had imagined, and that

my eyes were the most beautiful he had ever seen. It took such an immense effort of concentration to unite Ingrid as she had been up to now with the Ingrid of the photo, speeding up the voice, rolling the R's, making the S's more evidently liquid, so Ingrid might fly and get under Greg's skin, so much so that the tremor of emotion which I felt passed unnoticed.

This was about six months ago. Since then we've continued to phone and write to each other, and recently we've begun to talk about meeting: I might go to Boston, who knows? A large part of my life revolves around these calls; anything I see or that happens to me is modified and becomes part of the script of the next call, and sometimes I even rehearse. In the last nine months I haven't done any performances; all my creative energy goes into Ingrid and Greg. And what's more, I'm in love. I've fallen in love with Greg and I think he has fallen in love with me. I feel as if I'm mixed up in a strange fiction. There are times when I'm unsure whether it's a love dilemma or a script problem for a performance. And I feel the same with him on the phone, I feel at home in this Ingrid, the Ingrid he's taken for real. Maybe it's my best performance yet, a performance about Platonic love. Gina, what do you suggest? How can I emerge from this? Should I evaluate it as an artistic or a strictly personal problem? Do you think meeting would help me solve this mess, or would it just make things worse?
Yours,
Ingrid

INGRID

Dear Ingrid:

Reading your letter, I have to admit, the first thing that came to mind was that you were a freak, an artist who never made it career-wise, abusing her few skills to the point of messing up her private life, who would do well to get yourself off to a shrink right away. It was a biography of self-indulgence, I thought, bothering other people by creating romantic stories out of your failures. This is such a beautiful and amazing story. Forget everything I started my letter with. I love it. I am totally jealous.

Your confusion about whether this might be a script problem in your best performance or a "love dilemma" is essentially the confusion of love. You can't believe that you really love him, and that he really loves you; maybe you are more overwhelmed by the fictional aspect of your romance than he his. He's twenty-nine, gorgeous, and he loves you, even if you're not in the best shape anymore! I cannot really tell how you will get out (or not get out) of all of this. So why get out of it? Don't. Carry on. The question whether this is an artistic problem or a personal one is a bit tricky. You definitely abused your artistic skills to make that little angel fall in love with you, but so what? Who wouldn't forgive you? I guess you did the right thing in letting the story follow its course to that point, so I suggest that you keep on. I definitely think you should meet him. An encounter will transform all the fictitious elements of your love story into real ones – as far as this is possible at all in love.

Yours very truly,

Gina

Lawrence Bailey (born 1976, Stoke-on-Trent, UK) is a sculptor living and working in Amsterdam.

Jay Battle is an artist living in Brooklyn who draws his inspiration from the beach houses of southern California. His iconic works are very well-known in distant galaxies, just not this one.

Mary Caponegro is the author of several collections of fiction including *Tales From the Next Village*, *The Star Cafe*, *Five Doubts*, and *The Complexities of Intimacy*, as well as translated selected works, *Materia Prima*, in Italian. She currently is working on a novel, *Chinese Chocolate*. Mary is the Richard B. Fisher Family Professor of Writing and Literature at Bard College. She is also a big fan of Rita McBride.

Erin Cosgrove is a level 12 chaotic good rogue with long black hair and piercing black eyes. Strength: 13, Intelligence: 15, Wisdom: 17, Dexterity: 12, Constitution: 14, Charisma: 14. Recently, Erin has lent her short sword and her uncanny savvy of arcana to the *Valley of the Wearlynx*, *Curse of the Rat King*, and *The Penitent Necromancer of Darkhelm's Keep* campaigns. She has also written a series of self-help books including *Men are from Mars, Merfolk are from Neptune*, *Mutton Stew for the Barbarian Half-Orc Soul*, and *Loving your Halfling: Get All the Love You Deserve at Half the Size!*

Cristina Gómez Barrio was born 1973 in the Alhambra. She makes drawings, studies the color white in performance, takes photographs, and dreams. **Wolfgang Mayer** was born 1967 in Wertach, Allgäu, as the son of Klaus Kinski and Bonnie Tyler. He works with watercolor, bricollage, and video. In 1998, they founded the performance group Discoteca Flaming Star, in which they work collaboratively and with others. "DFS is meant to be a mental space open to all kinds of artists for experimentation and pleasure. We ask and are asked to collaborate, to

Notes on Contributors

make soundtracks, to fight with glamorous intelligence, and to suffer anger and melancholia. We work with monsters and we want to perform miracles. DFS is a space to challenge the world armed with the weapons of innocence and mystery. We play to heal amnesia, indulging in appropriated songs, hoping to plant roses and to enter your paradise. . . ."

Matthew Geller is an artist who lives in New York City.

David Gray likes deep-sea fishing, baked beans, *catalog raisonées*, and drinking in the Baur au Lac; he is President of the Gilles de Rais Society.

Pablo Helguera could be:
a) A 34-year-old Mexican who barely manages to survive in Brooklyn.
b) An opera aficionado who records his arias on 19th-century phonographic records.
c) An artist who has performed at MoMA and at several pretentious biennials.
d) Author of the books *Endingness* and *The Pablo Helguera Manual of Contemporary Art Style* (forthcoming).
e) All of the above.
f) None of the above.
g) Both.

Michele Hierholzer is a decorated Coast Guard veteran whose considerable energy is now being put to use counseling troubled adolescent boys. Other recent accomplishments include a silver medal for best dwarf geranium arrangement at the Nürnberger Blumenfest.

Philippine Hoegen is an artist born in Austria in 1970, now living in Istanbul, Turkey.

Notes on Contributors

Diana Kingsley is an artist living in New York City. Her most recent solo shows in New York include *Lurkers and Rogues* at Leo Castelli Gallery and *Lovely Swallowed Whole* at Bellwether Gallery.

Matthew Licht is a writer who lives in New York. He's not in the habit of giving advice. Madonna hadn't even asked his opinion when he told her she was a nice kid, but she'd better give up show-biz if she didn't want to get hurt. His stories have been published in *Screw*, *Juggs*, *Howler Monkey*, and *Crimeways*. He lists his current address as Missing in Nicaragua.

Rita McBride is an artist particularly happy to have been born in 1960. Although her life pre-implant(s) was full of abrupt crises, artistic successes, and otherwise rich experiences, she now enjoys a status of eternal invention that only her generation can be afforded. She is a frequent and coveted visitor of the famed Montmarte Studios in Florida.

Willem Oorebeek thinks that (gathering) knowledge begins with a sense for printed matter; this is how his love of printing emerged. His persistent attention to the mechanics and procedures of printing, his analyses of printed media, and his striving to reveal the essence of image use has led him on an odyssey through the entire realm of Gutenbergian descendants. *Myways* has helped Oorebeek redefine an extensive formulation of the verb genre. He considers it purely serendipitous to add something of his own to a document of such current value to the art world.

Jackson Perry toils in the art world and writes in his spare time. His hobbies include telephonic cocktails, napping, and sociology.

Notes on Contributors

R. H. Quaytman is an artist living in New York. She is a founding member and Director of Orchard, New York. She is past her prime, owns a poodle, and seems to show her work often in Poland.

Kimberly Sexton is an artist living and working in New York City. She finds time to write when not making sculpture, drawings, photographs, or love.

Gordon Tapper is a New York-based *flâneur*, a sedulous kibitzer, and a dilatory composer of words. His contribution to *Myways* marks the first time, to his knowledge, that he has engaged in cross-gender ventriloquism.

Erica Van Horn is a writer and artist now working in Tipperary, Ireland, after many years in London, Paris, Chicago, and New York. Her narrative usually encompasses the line of small domestic objects and their situation, but she is well aware of the larger fictions of all our lives.

Marcel Vos, born in 1942 in Lichtenvoorde, The Netherlands, is an art critic living and working in Amsterdam.

Myways is the final of four Ways books conceived by Rita McBride. The Ways books – *Heartways*, *Futureways*, *Crimeways*, and *Myways* – exploit and decipher genre writing with an entertaining and refreshing collective structure. The books include contributions from more than fifty artists, architects, writers, journalists, curators, and critics.

Heartways: The Exploits of Genny O; edited by Rita McBride and Erin Cosgr
ISBN 1-55152-160-1

Futureways; edited by Rita McBride and Glen Rubsamen
ISBN 1-55152-172-5

Crimeways; edited by Rita McBride and Matthew Licht
ISBN 1-55152-173-3

Myways; edited by Rita McBride and David Gray
ISBN 1-55152-198-9